IMAGINE A CITY THAT REMEMBERS

Querencias Series

Miguel A. Gandert and Enrique R. Lamadrid, *Series Editors*

Querencia is a popular term in the Spanish-speaking world that is used to express a deeply rooted love of place and people. This series promotes a transnational, humanistic, and creative vision of the US-Mexico borderlands based on all aspects of expressive culture, both material and intangible.

Also available in the Querencias Series:

The Latino Christ in Art, Literature, and Liberation Theology
 by Michael R. Candelaria

*Sisters in Blue/Hermanas de azul: Sor María de Ágreda Comes
 to New Mexico/Sor María de Ágreda viene a Nuevo México*
 by Enrique R. Lamadrid and Anna M. Nogar

Aztlán: Essays on the Chicano Homeland, Revised and Expanded Edition
 edited by Francisco A. Lomelí, Rudolfo Anaya, and
 Enrique R. Lamadrid

Río: A Photographic Journey Down the Old Río Grande
 edited by Melissa Savage

Coyota in the Kitchen: A Memoir of New and Old Mexico
 by Anita Rodríguez

Chasing Dichos through Chimayó by Don J. Usner

Enduring Acequias: Wisdom of the Land, Knowledge of the Water
 by Juan Estevan Arellano

Hotel Mariachi: Urban Space and Cultural Heritage in Los Angeles
 by Catherine L. Kurland and Enrique R. Lamadrid

Sagrado: A Photopoetics Across the Chicano Homeland
 by Spencer R. Herrera and Levi Romero

IMAGINE A CITY THAT REMEMBERS

The Albuquerque Rephotography Project

Anthony Anella and Mark C. Childs

Foreword by V. B. Price

University of New Mexico Press • Albuquerque

Library of Congress Cataloging-in-Publication Data
Names: Anella, Anthony, photographer, author. | Childs, Mark C.,
 1959– photographer, author. | Price, V. B. (Vincent Barrett),
 author of introduction, etc.
Title: Imagine a city that remembers: the Albuquerque
 rephotography project / Anthony Anella and Mark C. Childs;
 foreword by V. B. Price.
Description: Albuquerque: University of New Mexico Press, 2018. |
 Series: Querencias series | Includes bibliographical references
 and index. | Identifiers: LCCN 2017058461 (print) |
 LCCN 2018025968 (e-book) | ISBN 9780826359780 (e-book) |
 ISBN 9780826359773 (pbk.: alk. paper)
Subjects: LCSH: Albuquerque (NM)—History—Pictorial works. |
 Repeat photography.
Classification: LCC F804.A3 (e-book) | LCC F804.A3 A64 2018 (print) |
 DDC 978.9/6100222—dc23
LC record available at https://lccn.loc.gov/2017058461

Portions of this book were originally published in *Never Say Goodbye:
The Albuquerque Rephotographic Survey Project* (Albuquerque: Albuquer-
que Museum, 2000).

Cover photographs: (black and white photograph) courtesy of the
Albuquerque Museum, Ward Hicks Collection, Gift of John Airy,
1982.180.36 7; (color photograph) courtesy of Krista Elrick.
Back cover photograph couresy of the Albuquerque Museum

Designed by Lisa Tremaine
Composed in Futura Std and Chaparral Pro

To Cara, *mi querida*
A. A.

To the community who made this happen
M. C. C.

CONTENTS

FOREWORD

V. B. Price

Foreword to the Original 2000 Publication of *Never Say Good-Bye: The Albuquerque Rephotographic Survey Project*

As Gertrude Stein once wrote about roses—"a rose is a rose is a rose"—so it could be said that a place is a place is a place. No matter what it is or where it is—if it's Paris, Anton Chico, New York, Santo Domingo, or Roy—every place has its own irreplaceable character and identity, its own particular being, its own DNA, if you will, its own soul, no matter how threadbare or dispirited it might have become. And Albuquerque, New Mexico—this much maligned and misunderstood place—has too.

That's what makes *Never Say Good-Bye: The Albuquerque Rephotographic Survey Project*, by architect Tony Anella and urbanist Mark C. Childs, so useful and intriguing. The authors give their full seriousness and intelligence to the task of exploring and explaining—in the daily press—the historical development and unique personality of New Mexico's only metropolis. In doing so, they join a long and distinguished list of urban patriots who've struggled for more than three decades to preserve Albuquerque's fascinating history from the rapacious demands of constant and random growth.

From May 1998 to January 1999 Anella and Childs published ten articles apiece on the lessons of urban history in the *Albuquerque Tribune*, each accompanied by a historic photograph of an Albuquerque site or building, taken mostly from the Albuquerque Museum's mammoth archive, and a current photograph of the same place, taken from the exact same spot by photographer Krista Elrick. The "rephotographic technique" of observing change was pioneered by Mark Klett in his book *Second View: The Rephotographic Project*. The comparative technique can be used as a model for the visual analysis of historic change virtually anywhere, in the countryside or in cities large and small.

As public intellectuals, Anella and Childs, writing both from professional perspectives and from a deep appreciation of Albuquerque and its high desert landscape, perform a community service, stimulating thought and debate that is in the best tradition of popular urban journalism. They understand and practice with enthusiasm the sentiments behind Louis Mumford's educational prescription in his *The City in History*: "The prime need for the city today is for an intensification of collective self-knowledge, a deeper insight into the processes of history, as a first step towards discipline and self-control."

Anella writes straightforwardly in the title article of the collection, "By juxtaposing historic and contemporary photographs of Albuquerque, we hope to show both positive and negative examples of our development. We hope that this comparison of Albuquerque across time will sensitize the people of Albuquerque to both good and bad design, thereby raising their expectations for quality."

In a piece entitled "A City Shaped by Water," Mark Childs observes that the notion of a "water-service boundary . . . a geographical limit" to where the city will send the precious resource is "the more sensible course" than centrifugal sprawl. It's better "to build on the century of investment made in the well-and-pipe city, to repair old pipes before building new, to conserve well water before drilling new wells, and to revitalize neighborhoods before paving over the desert."

Anella and Childs's project has struck a sympathetic and positive cord with many in this city. It received financial support from banks, contractors, real estate developers, and architects. And it was awarded a major grant from the New Mexico Endowment for the Humanities, an "environment and preservation grant" from the Albuquerque Community Foundation, and the prestigious 1999 Heritage Preservation Award from the New Mexico Office of Cultural Affairs.

In an oblique but telling way, this exhibition connects two pivotal efforts to conserve Albuquerque's unique identity during a period of aggressive growth and change. One started more than thirty years ago when citizen volunteers were successful in lobbying city hall to preserve open spaces and natural landmarks around the city and at the same time protect the city's precious but dwindling cache of historic buildings. The other, in full flower today, in which activists are struggling to deflect energy from the city's long devotion to sprawl development and use it to invigorate a financially and ecologically successful infill strategy.

Never Say Good-Bye draws attention to Albuquerque's paradoxical mania for change and its countervailing passion for continuity. One article, and juxtaposing photographs, deals with a North Valley catastrophe, the chopping down of an immense cottonwood tree at the end of Montaño Road as it dead-ended at Rio Grande Boulevard. Long a symbol of North Valley community pride, the tree was demolished early in the morning to avoid protesters and to make way for the passionately hated Montaño Road Bridge. The two photographs are among the most striking

in the collection, one of the luxurious cottonwood (*alamo*) growing like an enormous green thunderhead out of the valley floor, the other a photograph of a sterile roadway and bridge exhibiting the oxymoron of an "engineering aesthetic."

Anella writes in that piece that the bridge did not solve the West Side's transportation problems "and has only made other parts of the city's transportation problems worse." He calls it a $30 million "quick fix" that ended up in an all too familiar "lose-lose" situation.

On the other hand, a piece on conserving and reusing the old Albuquerque High School campus praises the preservation of public buildings because they are "opened to the shared experiences that help create a common bond of history."

In a piece called "Learning from Los Griegos," Childs links eighteenth- and nineteenth-century Hispanic farming villages in the North Valley with contemporary infill ideas of new urbanism. "One of the hot urban planning concepts of the 1990s," Childs writes, "is the 'urban village.' Urban villages are neighborhoods of a few thousand people within a larger city that include not only a collection of houses but also civic places such as schools, community centers, cafés, and plazas. Many of the great cities of the world have this pattern."

If we could learn about community from Los Griegos in the 1880s, "modern, purely residential cul-de-sac development" of say twenty-five homes "could become villages— not walled collections of bedrooms and garages, keeping the world at bay, but homes that share civic spaces with each other and with other neighborhoods."

Anella and Childs believe in the practical knowledge to be gained from urban historic research. To learn from how a place has changed, to compare its past with its present, to preserve the evidence of its development are all actions that signify the place itself is being treated with respect, that it's seen as being more than just a place in which to make a financial killing and get out, and more than a place to be colonized by generic franchises and housing types and by people who have no feel for its genuine uniqueness.

When a city starts to take itself seriously, it does what human beings do when they become interested in their own lives. A city, as Mumford prescribed, searches for self-knowledge, for why it came to be the way it is, and how it can make the most of its unique potential.

Nothing's worse for people, or for places, than disrespectful change. Such callous change, which is always coercive, obliterates a place's identity in the same way as exploitative colonialism does, which itself resembles the kind of bullying and brainwashing that tyrants use to hold on to power. Anella and Childs show that economic development in Albuquerque and other ballooning midsized cities can be accomplished creatively, without local identity being erased and the existing local economy undermined by insensitive boom-and-bust land speculation and fringe development.

Their views seem to me to be very close to those gentle, life-affirming principles of Daoism known as the

"wu-forms"—*wuwei* ("non-coercive activity"), *wuzhi* ("unprincipled knowing"), and *wuyu* ("objectless desire"). Philosopher Roger Ames, writing in the summer 1999 issue of *Philosophy Now*, explains: "Simply put, to the extent that coercion is an element in [any] relationship, the creative possibilities are accordingly diminished. 'Unprincipled knowing' means that in seeking to understand the world around one, one must approach each experience . . . [with] an awareness of the bottomless complexity of particularity . . . [which] requires an uncompromising effort to take things on their own terms. And 'objectless desire' means cherishing the dynamic relationships that bind one into one's world while relinquishing any need for exclusivity or possession."

Never Say Good-Bye takes Albuquerque on its own terms. Anella and Childs look lovingly at the complexity of this particular place and make sense of it. They urge us to take control of our city's destiny and not be coerced into sanctioning the kinds of changes that diminish our creative possibilities. They help us resist turning over our sense of identity to those who don't understand that where we live is a place, like all others, that deserves an abiding, appreciative, and informed respect.

The View from 2017

A culture of civility, respectful and diligent communication, a striving for the common good—these are the fundamental elements of a healthy municipal polity. But over the last sixteen years we've seen hope for civil discourse in Albuquerque crumble before our eyes. Albuquerque has never really been the same politically since the Montaño Road Bridge controversy in the late 1990s. In a prolonged battle over decades, government and business interests finally got the upper hand and ran roughshod over citizens who were opposed to benefiting traffic flow to the west side of the city at the expense of traffic jams in the North Valley. Since 2000 national political polarization has infected local discourse in both the city and Bernalillo County, trickling down from smash-and-grab politics in the state capital. Though politics in New Mexico has always been something of a blood sport, Albuquerque has had moments in the 1970s and early 1980s of mind-expanding political give-and-take that resulted in one of the largest open space programs in the country, in a successful historic preservation movement that countered the wrecking ball of urban renewal, and in the preservation of the riparian habitat of the Rio Grande that runs through the middle of the city. But lately, public discussion and policy evolution have been replaced by zero-sum, top-down policy by fiat.

We've seen this most graphically in the last six years. City residents have lived under a cloud of fear and grief over numerous killings by police of unharmed, mentally infirm civilians. There were so many shootings, in fact, that the US Department of Justice began investigating the Albuquerque Police Department four years ago, finding the department was habituated to using excessive force. But after heated public debate and official stonewalling, no

substantial departmental changes have been made so far. The mayor of Albuquerque bucked nearly fifty years of tradition in the Rio Grande bosque, over vigorous and impassioned opposition from the environmental community, to begin turning a beloved semi-wilderness riparian environment into something considerably more park-like and less friendly to wildlife. Much like the destruction of the great cottonwood at Rio Grande and Montaño Road NW (see "Remember the Alamo," page 36), the city started blading a walking path in the wild bosque before its defenders were aware negotiations were over. People who had worked more than half their lives to rescue the bosque from neglect and abuse suddenly found their treasured environment checked off on a political look-good list by what many considered a two-bit politician aspiring to higher office.

With the Albuquerque Rapid Transit (ART) bus system, that same mayor made another policy decision by executive fiat over the outcry of virtually every business owner along Central Avenue. The $120 million project went through a feasibility study phase in 2011, but business owners along Central Avenue where the bus will travel swear they heard little or nothing about it. The city applied for funding in 2014, and apparently no one heard about that either. Then in 2016, with plans fully developed, the city began to hold public meetings. Even after it became clear that major players didn't want ART, the city rammed it through anyway, tearing up the street even as ART opponents took the plan to the Tenth Circuit Court of Appeals. People who depend on Central Avenue for their livelihood feel that the lack of civil discourse is flushing their financial futures down the drain.

In Bernalillo County, a massive, master-planned community on the southwest mesa called Santolina, owned by the British bank Barclays, met with county commission approval over the passionate opposition of South Valley residents and farmers fearing a threat to their water supply. Santolina promised to bring in 90,000 new residents and supply 76,000 new jobs. Despite intense public scrutiny, no one could figure out how the development would pull off such a miracle when no one else in the city or state could do anything even approaching that. Opponents worried, too, that Santolina would become yet another taxpayer subsidized "zombie development," a classic kind of developer Ponzi scheme in which public funds are dispersed, roads are bulldozed, house pads poured, construction started, and then the fantasy hits the force field of reality and the whole project is silently abandoned with few dwellings actually sold and occupied. Major cities in the Southwest are plagued by overbuilding and zombie subdivisions. Some estimate more than ten million empty houses blight the outskirts of Las Vegas, Tucson, Phoenix, Albuquerque, Denver, and many suburbs in West Texas and Southern California.

But even in this discouraging and fraught political environment, Albuquerque's pervasive sense of place is far from being defaced beyond recognition. Despite decades of invasion by franchise architecture, a sprawling cityscape, and congestion brought on by abysmal traffic planning,

Albuquerque's open space laws, its museums, its historic districts, its rich diversity and creative community, and its magnificent natural setting still help the city resist being overwhelmed by disrespectful growth. As the University of New Mexico's website describes its hometown, Albuquerque is still a "city that's simultaneously cosmopolitan and soulful, urban and rural, and brimming with lights and possibilities." Even the last sixteen years of civic tension and careless leadership can't wash that away.

Anthony Anella

What is honored in a country will be cultivated there.
—Plato

Unless someone like you cares a whole awful lot, nothing is going to get better. It's not.
—Dr. Seuss, *The Lorax*

Imagine a City That Remembers: The Albuquerque Rephotography Project is an update and expansion of a series of essays and accompanying photographs originally published in the *Albuquerque Tribune* from May 5, 1998, to January 26, 1999. In 2000 the essays and photographs were exhibited at the Albuquerque Museum and published in an exhibit catalogue with the title *Never Say Good-Bye: The Albuquerque Rephotographic Survey Project.*

The essays and photographs intend to foster *querencia*, a Spanish word meaning love for place through knowledge of the local environment and history. As I wrote in the initial *Albuquerque Tribune* essay "Never Say Good-Bye," by presenting a series of paired images—an historic photograph alongside a contemporary photograph of the same place— "we hope to foster respect for Albuquerque's natural and cultural heritage, even among those people who have moved here recently, who will move here in the future, and who do not otherwise share an emotional attachment to this place."

In today's rapidly changing world, it is becoming increasingly rare for people to live their entire lives in one place. People move where the opportunities for advancement take them. This is especially true in the United States, which is a nation largely made up of immigrants. Most of us—with the notable exception of Native Americans—are from somewhere else. Moving is in our DNA. Located on historic Route 66, the most famously romanticized road in the country, Albuquerque is part of this cultural story: the "go west, young man" dream of America. What is lost in all the moving about is querencia, which springs from getting to see both the beginning and the end of the story play

out in the same place. *Imagine a City That Remembers* offers a simulated experience of seeing both the beginning and end of the story so that, as a community, we might better understand why this place matters.

We take care of the places we love. We do so altruistically and also selfishly because at some level we recognize that doing so makes our lives better. Unfortunately, the prevailing Albuquerque real estate culture operates on a false dichotomy that keeps altruism and self-interest separate. This leads to a zero-sum game of win-lose instead of win-win. Most Albuquerque real estate developers either can't or choose not to recognize that quality development serves *both* their own self-interests *and* the interests of the community as a whole. This false dichotomy leads to a division between those who develop our community and those who must endure—for better or for worse—the consequences of that development. This division threatens to tear Albuquerque apart. The fact is, we are all in this together, and as Abraham Lincoln reminded us 158 years ago, "a house divided against itself cannot stand."

The Jewish philosopher Hillel unifies altruism and self-interest with the following insight: "If I am not for myself, who will be for me? Yet if I am only for myself, what am I?" Albuquerque's enlightened developers understand this. They understand that quality development enhances Albuquerque's quality of life, and that enhancing Albuquerque's quality of life results in the appreciation of real estate value over time. They understand that good business is not a zero-sum game—that their self-interest as developers is tied to the interests of making Albuquerque a desirable community in which to live. What distinguishes enlightened from unenlightened real estate development is a long-term versus short-term commitment to place. Enlightened developers understand it is in their self-interest to develop Albuquerque with an eye for quality. Reputation matters. When you make a long-term commitment to a place, you also assume responsibility for your own reputation in that place. You honor that place because you are committed to living in that place over time.

The Pueblo Indians, who have lived here the longest, think of time in terms of seven generations—four generations back and three forward—and they mark time with ceremonial dances performed according to the cycle of the seasons. The Pueblo culture's concept of time is fundamentally different from that of Western society. It is rooted in a natural reality outside of and larger than the Pueblo Indians themselves. What their ceremonial dances celebrate is the transgenerational continuity of time as well as a profound cultural connection to place. The dances symbolize what Pueblo Indians honor and are an effective way for them to ensure their cultural values are perpetuated across time. Their children might not remember the stories they read a month ago, but they are likely to remember the stories they danced, especially when the dances are repeated annually according to the cycle of seasons. Perhaps this explains the remarkable resiliency of Pueblo culture.

Western society marks time to a reality of its own making: the dual rhythms of a quarterly accounting system

and a two-, four-, or six-year election cycle. Western society cuts up land in the same arbitrary way it marks time. A bird's-eye view of the United States reveals a giant grid imposed on the natural landscape: a subdivided world of square-mile sections. Albuquerque reflects this grid by being divided into quadrants by Central Avenue (old Route 66) running east to west and the railroad tracks running north to south. The relationship of this grid to the landscape is arbitrary. What this grid honors is a matrix for a certain man-made order that frames our view of the world as a linear progression that separates the man-made from the natural. Unfortunately, according to this view of the world, progress is too often defined quantitatively rather than qualitatively.

Aldo Leopold, one of the world's great conservationists, who lived in Albuquerque from 1918–1924, comprehended the disconnect between long-term and short-term thinking in his essay "Thinking Like a Mountain." For Leopold, to think like a mountain meant to consider our long-term self-interest in an impartial, objective way that considered the long-term viability of the system as a whole. Out of such impartiality, Leopold asserted a land ethic that included taking care of all living things, not just the human or the man-made: "Examine each question in terms of what is ethically and esthetically right as well as what is economically expedient. A thing is right when it tends to preserve the integrity, stability, and beauty of the biotic community. It is wrong when it tends otherwise" (1949, 224).

Leopold's land ethic rings especially true at this moment in human history as we begin to understand ourselves as being part of nature, not separate from it. To ignore the long-term ecological health of our planet and all living things on it is to jeopardize the health and well-being of our children and grandchildren. Leopold's land ethic also rings true as we begin to comprehend the difference between growth and development. This difference has to do with quality. Growth is quantitative: it means getting bigger for the sake of getting bigger without regard for the carrying capacity of the earth. Development is qualitative: it means getting better at living within our means, both economically and ecologically. To think like a mountain is to care for the earth with an interest in securing the inheritance of a beautiful and healthy environment for our children and grandchildren.

Querencia means caring for a place for the sake of our children and grandchildren. In Albuquerque, a city falsely divided between the developers of our community and the citizens who endure the consequences of that development, querencia means recognizing that we are all in this together, and that "a house divided against itself cannot stand." Querencia also means the kind of long-term caring for the earth that Leopold implies with the phrase "thinking like a mountain"; the kind of caring Plato teaches with his insight, "what is honored in a country will be cultivated there"; the kind of caring the Lorax reminds us is essential if things are "going to get better" in this place we call home.

ACKNOWLEDGMENTS

1998 Preservation of Albuquerque's cultural heritage along with conservation of Albuquerque's natural resources can only be achieved if people choose to care. We are grateful for the generous support of the New Mexico Endowment for the Humanities, the Albuquerque Community Foundation, the Bank of America Private Bank, and the Albuquerque Museum for allowing the newspaper series to take on a longer life in the form of an exhibit and accompanying exhibit catalogue.

We are especially indebted to the following individuals and organizations for sponsoring the articles to help us defray the cost of producing the photographs (listed in chronological order of sponsorship): Robert J. Stamm, Donald H. Tishman, David A. Ater, Nations Bank Private Client Group, Parkland Hills Inc., Ann Simms Clark, John L. Rust, the Institute for Civic Art and Public Space, Robert Slattery Construction Inc., BPLW Architects and Engineers Inc., Sun Graphics Inc., Sites Southwest Inc., and the Arcadia Land Company.

We would also like to thank V. B. Price for his encouragement of the project and for his example as a devoted critic of our beloved Albuquerque; George Anselevicius, FAIA, Dean Emeritus of the UNM School of Architecture and Planning, for his tough-minded commitment to excellence in education; James Moore, the director of the Albuquerque Museum, for his early and enduring support of the project and for his many thoughtful suggestions; Mo Palmer, the photo archivist at the Albuquerque Museum with whom it is a pleasure to work thanks to her wry sense of humor that we imagine can only have been derived from her encyclopedic knowledge of Albuquerque's photographic history; Krista Elrick, an integral part of the Albuquerque rephotography project team, for her skill, dedication, and patience as a photographer in matching the historic

images with contemporary photographs; Edgar Boles, City of Albuquerque Historic Preservation Planner, for his support of our efforts by nominating the project for a 1999 Heritage Preservation Award from the New Mexico Office of Cultural Affairs; graphic artist Tom Antreasian and curator of exhibits Bob Woltman at the Albuquerque Museum for their many insights regarding the exhibit and exhibit catalogue; and Jack Ehn, Kate Nelson, and Scott Ware for the civic-minded way they manage and operate the *Albuquerque Tribune* in the service of our town's intellectual and cultural quality of life.

Finally, we would like to thank our families, and especially our children, for the inspiration.

2017 As you can see from the people listed above, it takes a community to make a book, and we want to thank all of you who helped us. It also takes a robust set of institutions—a press, university and city photo archives, foundations, museums, newspapers, state and city historic preservation organizations, a public art department, a city planning department, and many others. The ongoing work of these institutions and public support for their work is essential to learning from the past and creating a vibrant future.

For this update and expansion of the original series of essays and photographs, we want to thank Enrique R. Lamadrid and Miguel A. Gandert for inviting us to be part of the Querencias Series, as well as John W. Byram, former director, and W. Clark Whitehorn, executive editor, of the University of New Mexico Press for their support and encouragement. We are grateful to Maya Allen-Gallegos for her skillful help editing the manuscript. We would also like to thank UNM anthropology professor David E. Stuart for his generosity as a teacher and for his insights regarding human life in the Southwest; David Parsons, of the US Fish and Wildlife Service (retired), and Karl Malcolm, the regional wildlife ecologist for the US Forest Service, for their insights regarding what Aldo Leopold referred to as "the biotic community" in the Southwest; professor emeritus of English and gardener extraordinaire, Stanley Damberger, for his kind review of the essays; Alan Reed and Ike Eastvold for commenting on the Albuquerque open space essay based on their separate but equally inspirational examples of helping to preserve it; Richard Barish, an Albuquerque attorney and steadfast protector of the Rio Grande bosque; Geraldine Forbes, dean of the School of Architecture and Planning, and Kymberly Pinder, dean of the College of Fine Arts, for their leadership in reestablishing a vital cultural connection between the University of New Mexico and downtown Albuquerque; Frank Martínez for his inspiring example as a citizen leader who worked for more than

forty-five years to protect the integrity of Martíneztown; Ellen Babcock for her vision and dedication to working with the community; Glenn Fye, photo archivist at the Albuquerque Museum, for his help locating historic photographs; Robert Reck for making the contemporary photograph of the crossroads at Fourth Street and Central Avenue; and Lee Morgan for making the contemporary aerial photograph of Martíneztown.

Anthony Anella and Mark C. Childs

IMAGINE A CITY THAT REMEMBERS

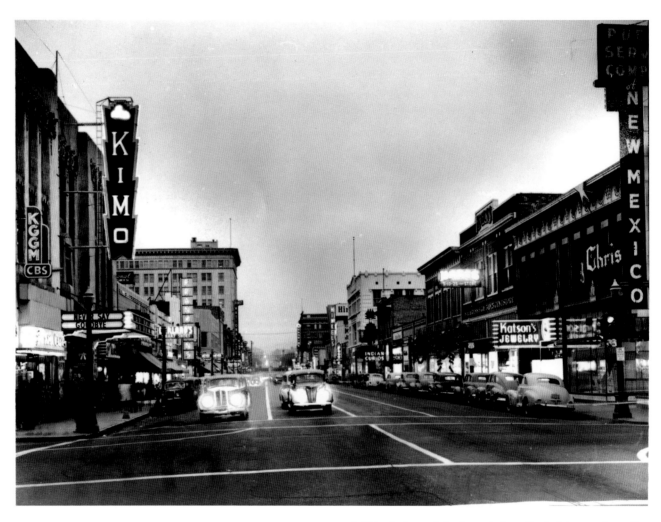

1946. This photograph looks east along Central Avenue from the northeast corner of Central and Fifth Street. The marquee for the KiMo Theatre reads "Never Say Goodbye." Courtesy of the Albuquerque Museum, Ward Hicks Collection, Gift of John Airy, 1982.180.367.

2

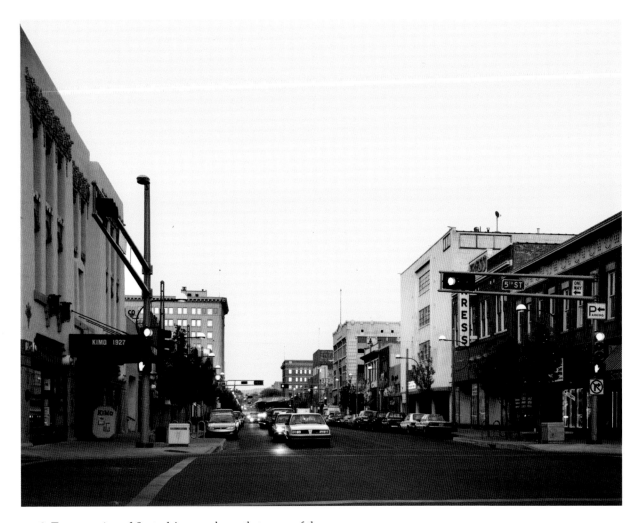

1998. The same view of Central Avenue shows that many of the buildings—including the KiMo Theatre—have been preserved and renovated, but the KiMo sign has been removed. In 2017 the city installed a replica of the original sign on the building. Photograph by Krista Elrick..

NEVER SAY GOOD-BYE
Anthony Anella

1998 If the Census Bureau is right, the Albuquerque metropolitan area could have close to one million people shortly after the turn of the century. The implications of this population increase in terms of water, land, housing, transportation, and the general quality of our urban life make this a critical juncture in our history. As we approach the millennium, the Albuquerque Rephotographic Survey Project seeks to take stock of what Albuquerque has been, what it is today, and what it could be in the future.

These essays present a series of paired images: an historic photograph alongside a contemporary photograph of the same place. By juxtaposing historic and contemporary photographs of Albuquerque, we hope to show both positive and negative examples of our development. We hope that this comparison of Albuquerque across time will sensitize the people of Albuquerque to both good and bad design, thereby raising their expectations for quality. We also hope that these photographs and the accompanying essays will help to foster respect for Albuquerque's natural and cultural heritage, even among those people who have moved here recently, who will move here in the future, and who do not otherwise share an emotional attachment to this place.

Photographs, because of their credibility as objective documents, have the unique ability to "compress time": to make the changes across time into artifacts. They capture a tangible sense of our history, our identity—as individuals, as members of families, and as members of larger communities. They help us to focus on the reality of our existence. As artifacts, they serve as powerful reminders of the important choices we have made and will make about how we want to live our lives, including how we want to build our community.

For example, the pair of photographs in this chapter compresses fifty-two years of our history and reveals subtle changes to downtown Albuquerque over time. Perhaps most remarkable—in light of other losses—is

the fact that the KiMo Theatre still stands. Built in 1927 by Oreste Bachechi as a Pueblo Revival showcase and restored in the late 1970s as a performing arts center, the KiMo continues to contribute to Albuquerque's quality of life. The photographs document our community's choice to preserve our past.

There is some irony in the fact that, in our information age of instantaneous news, photographs are too often used for their immediate impact—not for their ability to provoke thoughtful reflection. In this irony is an essential point of the comparison between historic and contemporary photographs of the same place: to promote a long-term versus short-term understanding of the wider issues and deeper forces affecting our city. How can bankers, developers, architects, and builders—the people directly responsible for shaping our community—as well as citizens and their elected representatives help make Albuquerque a better place to pass on to our children and grandchildren?

Another failing of instantaneous news is the conceit of poor memory. Or as Santayana warned, those who forget the past are doomed to repeat it. As the financial and commercial center of a poor state, Albuquerque has given the impression that it couldn't afford the burden of recollection. Unlike Santa Fe, which at times appears to have become a caricature of its history, Albuquerque, in its rush toward progress, has simply wanted to leave its history behind. But we do so at the peril of being seduced by a certain "realist" view that regards the fundamental forces of our development as unchangeable. By understanding the financial, entrepreneurial, regulatory, and political forces shaping our community, we can influence those forces so that they align with how we choose to live. By not saying good-bye to our past, we can learn to celebrate our city for what it is and what we want it to become.

2017

An essential point of the comparison between historic and contemporary photographs of the same place was—and still is—"to promote a long-term versus short-term understanding of the wider issues and deeper forces affecting our city" so that we might make better choices about how we want to develop our community.

One of the things that is different today, nearly twenty years after *Never Say Good-Bye: The Albuquerque Rephotographic Survey Project* was first published, is how the act of photography itself has changed. The digital age has transformed the medium of photography so that we can no longer trust it as an objective document. Our technical ability to manipulate pixels puts a lie to the adage "the camera never lies." The nineteenth-century chemical process that allowed light to be recorded on photosensitive film has been supplanted by a twenty-first-century electronic process that allows light to be simulated by a computer. The medium that previously had been a way to keep historians honest, today gives new meaning to the concept of historiography. History has always been subject to interpretation. Now it is subject to manipulation. Marshall

McLuhan's prophecy has indeed come true: "the medium is the message."

We can't put the digital genie back in the bottle. The technological manipulation of how we perceive the world is here to stay. Our only recourse is to emphasize ethics in how we use our technological capabilities. Journalistic ethics—the integrity with which the facts are reported—is all that keeps our fragile democracy from spinning out of control.

Another thing that is different is the absence of the *Albuquerque Tribune*. The venue where the original essays and photographs were first published no longer exists. The digital information age has put tremendous pressure on the traditional ink-on-paper form of getting our news. Many newspapers, like the *Albuquerque Tribune*, have gone out of business while simultaneously being replaced by an overwhelming number of digital news sources. By the time the original essays and photographs were first published in 1998, most of the commercial sources of televised news in the United States were owned by large corporations. General Electric owned NBC (later selling it to Comcast in 2013). The Walt Disney Company owned ABC. Sumner Redstone's Viacom bought CBS in 1999. Ted Turner started CNN in 1980, and Rupert Murdoch launched Fox News in 1996. Although each of these corporations has a distinct set of business interests and each is managed by different people, they all share a common goal: maximizing short-term profitability for their shareholders, which may or may not serve the common good.

In George Orwell's *1984*, "newspeak" is a language invented by a privileged elite of the government's "inner party." This privileged elite persecutes independent thinking as a "thought crime." Respect for individualism and the collective wisdom of individuals to govern themselves by voting is replaced by an intense cult of personality and the tyranny of "Big Brother." Several years ago, a luncheon panel of local news media professionals talked to a group of local architects about how to increase the visibility of architecture and urban design in the local media. The manager of one of the local television stations, a perfectly coiffured thirty-something, explained how each day a 9:00 a.m. meeting determines the content of the evening news. He told the audience the question that guides the discussion is, "What would Joe Six-Pack want to watch?" Not Joe Voter—Joe Consumer!

We *can* put the media genie back in this bottle. Unlike the digital age, which is subject to the immutable laws of physics, the ownership of commercial media is subject to the laws of the marketplace as regulated by the government. This is the problem. It also suggests a solution.

We the people can choose to stop watching or listening to news stations that appeal to us as consumers rather than as citizens of a democracy that depends on an informed electorate to function. In fact, we make this choice every time we contribute to KNME, KUNM, or KANW. We can insist on quality information over the sensationalized stories that are broadcast to promote the commercial interests of selling advertising. All we have to do is exercise our power as consumers and stop watching. If you doubt the

power we have as consumers, just look at the revolution of microbreweries that are producing quality beer in our town and in our country. They have the corporate breweries shaking in their boots.

In addition, because the people own the airwaves and the people license the airwaves through the Federal Communications Commission (FCC), the people can apply political pressure on the FCC to revoke the licenses of those media companies that fail to provide quantifiable social services. For example, as a condition of licensure, we already require the networks to provide emergency broadcasting capabilities (the ones that periodically disrupt the scheduled broadcast). Why can't we decide we want the networks to provide free air time to our political candidates? This would minimize the need for a candidate to raise so much money in order for her or his ideas to be heard. It would also likely lead to shorter campaigns since the media companies could not afford to provide free air time for long.

Nothing is wrong with media companies making money. But because they make money by "renting" the airwaves that belong to the people, society has a right to require socially beneficial services as a condition of the rental agreement. When the media companies merely make money without making society better, they compromise the genius of our community and of our country.

Little or no difference exists between a government tyranny and a corporate tyranny. The Big Brother syndrome is the same. In both cases the interests of an elite few suppress the ethics inspired by serving the common good.

Doing unto others as you would have them do unto you is replaced—at best—by do unto others what you can legally get away with, and—at worst—by do unto others what your lobbyists can persuade Congress to make legal. But corporations are not citizens in spite of what the Supreme Court would have us believe. Such mono-think leads to a deadly monoculture that is anathema to the intellectual diversity that has made our country great and that our city so desperately needs if we are to prosper in the face of our ecologic and economic challenges.

Albuquerque's greatest strength is the interaction of ideas and diverse ways of looking at the world that nurtures a culture of creativity and innovation and serves as an antidote to mono-think. If Albuquerque is to be successful in realizing this potential, it will need to attract, and keep, innovative and creative young people. They choose to work and live in places that offer opportunities for personal growth in their careers and places that offer culturally vibrant and naturally beautiful environments in which to live and raise their families.

This may be the most important point of *Imagine a City That Remembers*: to foster respect for Albuquerque's natural and cultural heritage so we can preserve the rich diversity that is both an antidote to monocultural thinking and an essential condition for innovation and creativity. By not saying good-bye to our past, we can learn to celebrate our city for what it is so that it might become a place where our children and our children's children can and will want to live.

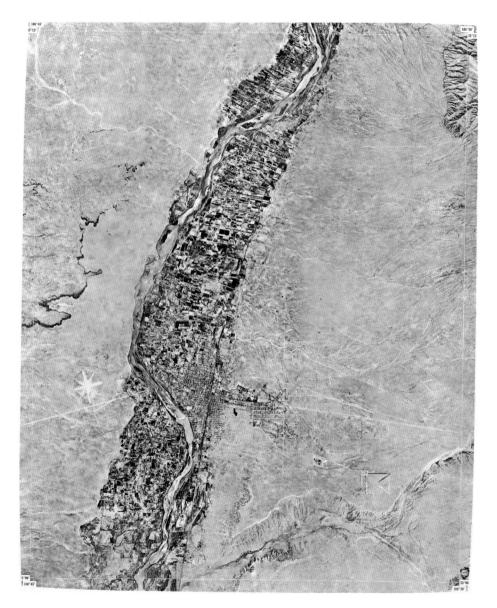

1935. This aerial photograph shows settlement primarily confined to the Rio Grande valley, except along Central Avenue where the new city of Albuquerque rises up onto the mesa. Courtesy of the Earth Data Analysis Center. Photograph by Three Hawks.

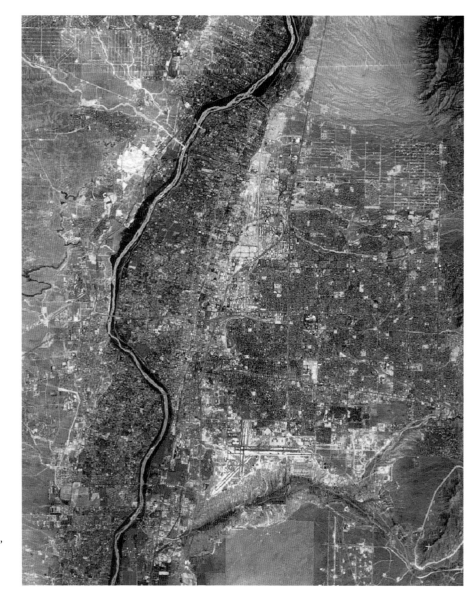

1997. By 1997 the city had exploded onto the east mesa while the original river community, at least from this view far above, appeared to remain intact. On the ground, however, it's clear that the river settlement is in danger of being overrun. Courtesy of the Earth Data Analysis Center.

A CITY SHAPED BY WATER
Mark C. Childs

1998 The flow of water carves the bends, twists, and oxbows of riverbeds and settlements.

Obtaining and controlling a supply of water requires the people to take collective action. Digging acequias, constructing dams, managing floodwater, disposing of sewage, drilling wells, and laying pipe have, since the dawn of cities, required that groups of people work together. There is evidence that the desire to manage water caused the rise of cities and city-states. And, as the worldwide myths of great floods attest, the ultimate inability of man to master the waters has washed away civilizations.

The local fit between climate, landscape, and technology govern a city's ability to manage water and the city's shape.

The 1935 aerial photo of the Albuquerque area shows two different forms of settlement. The ancient riparian settlement of villages, farms, and acequias along the floodplains of the Rio Grande dominates the picture. However, New Albuquerque's grid of streets and pipes rises up onto the desert plateau and forms a cross-axis to the river. These two settlements gave rise to separate local governments, numerous special water agencies such as the Middle Rio Grande Conservancy District and the Albuquerque Metropolitan Area Flood Control Authority, numerous neighborhood well associations and companies, and the city sewer system. And they played a role in the development of state water agencies and multistate agreements.

The 1997 photograph shows the explosive growth of the well-and-pipe city. This explosion presents two issues.

First, we must consider, as a community, if we wish to invest in a third ring of settlement. For the most part, the city has remained within the valley between the Sandias and the volcanoes. Expanding to the west beyond these limits will require a new water system.

Already the city is planning to pump water from the river and, to meet demand, is considering infrastructure to water the desert west of the volcanoes.

There is also talk of a water-service boundary—a geographical limit to where the city will provide water service. This, I believe, is the more sensible course—to build on the century of investment made in the well-and pipe city, to repair old pipes before building new ones, to conserve well water before drilling new wells, and to revitalize neighborhoods before paving the desert.

However, this will require regional cooperation. The city could refuse to extend water service, only to have Rio Rancho, Bernalillo County, and/or a new city develop a water system for the desert west. The battles over Intel's water use and county sewer and water agencies are only the beginning of the "discussion" about a new, far western ring of settlement.

Second, we must protect our monetary, cultural, and water investments in the acequia settlements.

Overlaying city boundaries on the 1997 photograph would show that, to a large extent, the city of Albuquerque is the land marked by the well-and-pipe settlement, and the river-bottom communities remain outside the city's jurisdiction.

This, however, is only the general view from the air. On the ground, the pipe-and-well city has seeped into the acequia settlements. "City" water and sewer is provided past the city's boundaries.

This liquid infrastructure had made possible the replacement of field and farm with housing developments designed for the mesas. Family-farm compounds are being demolished for walled cul-de-sacs. Lawns and desert xeriscaping are replacing cottonwood-lined acequias, alfalfa fields, and orchards. With fewer irrigated fields, the valley's water table, on which large trees depend, has been sinking. Drop by drop the acequia settlements are drying up.

The continued health of the acequia settlements is vital. It is simple foolishness to water landscapes with aquifer water when river water is available. Moreover, we should not carelessly abandon the ways of community that have adapted to this climate over centuries. For example, maintaining ditches keeps neighbors in touch with each other and the climate. Development should be carefully regulated in the valley to ensure its fit with the acequia settlements. No development in the valley should be allowed to abandon the ditches, houses should be clustered to retain fields and orchards, and ditch trails should be kept open or in some cases reopened. Furthermore, the region should, like settlements from Europe to the West Coast, buy development rights to existing farms. This would protect an irreplaceable resource and provide funds to families to maintain and perhaps expand their farms.

Where we, the citizens of the Middle Rio Grande, decide to invest our water is perhaps one of our most important decisions. Low-flow toilets and kitchen faucets are clearly an essential part of how we manage our water, but the larger questions of the size and shape of the city are of critical importance. Should we pump water to the desert west of the volcanoes? Should we build over the ancient, river-bottom farms? The flow of water shapes Albuquerque as surely as it forms the Rio Grande.

2017 Water, inevitably, continues to shape the city.

In 2008 Albuquerque opened its $450 million San Juan-Chama drinking water project. Studies for this project, according to the Bureau of Reclamation, began after World War I with the first survey begun in 1936, and the project was authorized by Congress in 1962 (PL 87-483). This far-sighted and far-flung project, in conjunction with effective water conservation efforts, has allowed the water level to rise in the region's aquafer.

At the same time, we have substantively expanded the metropolis onto the western lava flows. These new subdivisions continue the car infrastructure–intensive pattern that dominated the late twentieth century. Moreover, the creation of the Water Utility Authority has decoupled decisions about land use and water use and arguably made it easier to develop these unwatered lands. Any hope for a water-service boundary evaporated.

There have been a few successes in protecting the acequia landscape. A major example is the former Price dairy farm and adjacent properties that in 2014 became the 570-acre Valle de Oro National Wildlife Refuge. The site incorporates acequia-based farming within a wildlife preserve. The US Fish and Wildlife Service's (2016) website describes a central purpose of the site: "the refuge fulfills the goals of President Obama's America's Great Outdoors initiative to work with community partners to establish a 21st century conservation ethic and reconnect people, especially young people, to the natural world." In a different way, Los Poblanos Historic Inn and (USDA Certified) Organic Farm has built an international reputation by grounding itself in the history of the Middle Rio Grande farm landscape. Yet, the overall acequia landscape continues to disappear field by field, lateral by lateral, farm by farm. We need to develop programs that address the landscape as a whole.

BANKING'S INTEREST IN ALBUQUERQUE'S FUTURE
Anthony Anella

1998 In 1998 NationsBank N.A. of Charlotte, North Carolina, bought Sunwest Bank. I happened to go to one of the branches on the 18th of August, the day when the bank changed all its signs and officially opened its doors under the new name. That day marked the culmination of a long process that began prior to 1983 when the local owners of the old Albuquerque National Bank changed its name to Sunwest and positioned it for acquisition. As it turned out, this acquisition took place in two phases. First, in 1992 Boatmen's Bancshares Inc. of St. Louis merged with Sunwest. Then, in 1997 NationsBank bought Boatmen's. What happened in Albuquerque was part of a larger national trend. Economies of scale and management efficiencies made possible by the computer helped change the calculus of banking as a business.

The net effect of this consolidation on Albuquerque as a community remains to be seen. Will the loss of local ownership diminish the bank's perceived self-interest in serving and protecting the interests of our community as a desirable place to live? Or will the potential benefits of a large regional bank—one with broad experience funding innovative projects in other parts of the country—include enhancing Albuquerque's quality of life? In either case the issue is the influence this huge new bank's lending practices will have in shaping the development of our city.

Good business is premised on seeking the win-win. If possible, it is premised on the win-win-win: a win for the entrepreneur, a win for the lender, and a win for the community. This is true because where there is social need, there is also business opportunity. Timing is everything. In this age of instant gratification, "wins" are too often defined as short-term goals. Unfortunately, the short-term interests of an individual entrepreneur with a debt to service or a large public corporation with the responsibility of making quarterly financial reports to its shareholders may not coincide with the long-term interests of a

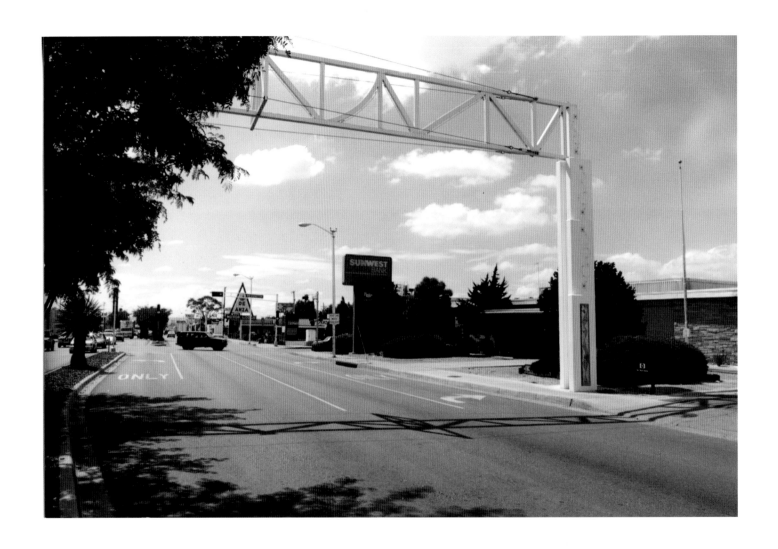

1997. The east Central branch of Sunwest Bank, at Washington and Central Avenue, as seen looking west through the Nob Hill Gateway. Note the name on the sign. Photograph by Anthony Anella.

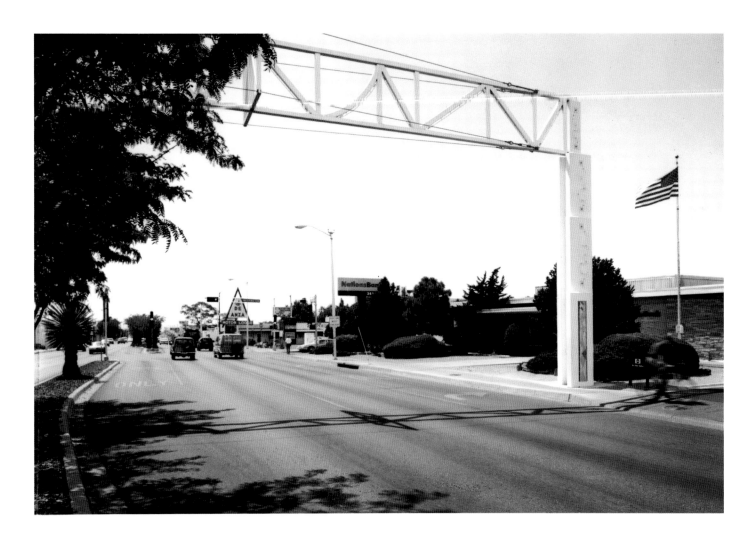

1998. In this photograph—taken only a year later—the ownership of the bank changed to NationsBank. Subsequently, the ownership of the bank changed again. In 2017 the name on the sign is Bank of America. Photograph by Anthony Anella.

community. And yet sustained and sustainable prosperity is in everyone's interest—including a bank's.

Witness a February 1995 report entitled "Beyond Sprawl: New Patterns of Growth to Fit the New California." The sponsors of the report—the Bank of America, the California Resources Agency, the Greenbelt Alliance, and the Low Income Housing Fund—believe that "California must pursue growth and development that is sustainable. Unfettered sprawl will make the state less competitive, burden taxpayers with higher costs, degrade the environment, and lower the quality of life for every Californian" (Bank of America et al. 1995). In addition to the remarkable diversity of views represented by the cosponsors, what makes this report so significant is its focus on the long term and on providing the "greatest benefits for ourselves and future generations."

The key word is "competitive." The Bank of America (headquartered in San Francisco) did not become one of the largest banks in the country and the California economy did not grow into one of the largest in the world without being competitive. And now—with all their experience—they are questioning the conventional pattern of development because it undermines their advantage. It may be too late for California. Businesses are already leaving because of its notorious transportation inefficiencies and costs of living.

But it is not too late for Albuquerque. Might not we learn from California's example and begin now to promote development that helps make our town more competitive because more efficient and more desirable as a place to live? And might not NationsBank—and the other banks doing business in Albuquerque—be persuaded that the sustained prosperity of our community is also in the interest of banking?

2017 As it has turned out, the answer to the two questions posed in the original 1998 essay has more to do with what John C. Bogle, the founder of the Vanguard Mutual Fund Group, calls the "pathological mutation of capitalism from owner's capitalism to manager's capitalism" (2009, 127) than with banking's perceived self-interest or with banking's experience funding innovative projects. In fact, viewed retrospectively in the prolonged aftermath of the 2008 banking debacle, these two questions seem naïve.

According to Bogle (2009, 127–28), "Since 1950, direct ownership of U.S. stocks by individual investors has plummeted from 92 percent to 26 percent, while indirect ownership by institutional investors has soared from 8 percent to 74 percent—a virtual revolution in the ownership structure. Our old ownership society is now gone, and it is not going to return. In its place we have a new agency society in which our financial intermediaries now hold effective control of American business." One result of this ownership

transformation is that the short-term self-interest of the manager has replaced the long-term self-interest of the owner in the oversight of our economic system.

The business model of a bank headquartered in Minneapolis or San Francisco is different from the business model of a bank headquartered in Albuquerque. This difference has everything to do with ownership. The out-of-state–owned banks have no real skin in Albuquerque's game. The local banks do. Witness which bank stepped up with $3 million to support "Innovate ABQ," one of the most promising long-term economic development ideas for Albuquerque to come along in years: the New Mexico Educators Federal Credit Union, now called Nusenda. Why? Because it is in the locally owned credit union's interest for Albuquerque to prosper over the long term.

Although it is still in the out-of-state–owned bank's interest for Albuquerque to prosper, prosperity for them is measured in shorter increments of time having more to do with their management's imperative of making quarterly profits for their shareholders than with Albuquerque's long-term economic well-being. The management of the out-of-state–owned banks adopts practices that maximize quarterly profit taking because their own compensation depends on it. As a result, they treat Albuquerque as little more than a remote profit center.

While it is true that the out-of-state–owned banks do not depend on Albuquerque for their business reputations, it is also true that the locally owned banks have filled the void created by the larger banks' lack of concern for customer service. Witness which banks charge the lower fees. It is in the locally owned banks' interest for that money to stay circulating in the Albuquerque economy rather than being whisked off to Minneapolis or San Francisco as an exorbitant charge for having a checking account or for bouncing a check. Insufficient funding is one of Albuquerque's biggest problems. But the lack of capital to finance our city's and our state's productive capacity is not just due to the fact that Albuquerque is the financial center of a relatively poor state. It is also because the out-of-state–owned banks lack interest in Albuquerque's long-term future.

The problem with banking is not exclusive to Albuquerque. Large, out-of-state banks have forgotten (or choose to ignore) that their primary business purpose is to serve their customers in the communities where they do business. Economist David C. Korten (2010, 44) explains the problem by making a distinction between "Wall Street Capitalism" and "Main Street Capitalism":

Wall Street is a world of pure finance in the business of using money to make money by whatever means for people who have money. Any involvement in the production of real goods and services is purely an incidental byproduct. Maximizing financial return is the game. To that end, Wall Street institutions have perfected the arts of financial speculation, corporate-asset stripping,

predatory lending, risk shifting, leveraging, and debt-pyramid creation.

In contrast, he continues,

Main Street is the world of local businesses and working people engaged in producing real goods and services to provide a livelihood for themselves, their families, and their communities. Main Street is more varied in its priorities, values, and institutions. Like the diverse species of a healthy ecosystem, its enterprises take many forms, from sole proprietorships and family businesses to cooperatives and locally owned and locally rooted privately held corporations. Achieving a positive financial return is an essential condition of staying in business, but most Main Street businesses function within a framework of community values and interests that moderate the drive for profit. (Korten 2010, 44)

The "real wealth" created by Main Street Capitalism has been trumped by the "phantom wealth" created by Wall Street Capitalism. This is especially harmful to smaller cities like Albuquerque that are treated like colonial dependencies by Wall Street. There is very little difference between the way Britain overtaxed the early American colonies and the way big banks overcharge customers in smaller cities like Albuquerque for their banking services. Britain viewed America in the 1700s the same way the big banks view Albuquerque today: as a colonial profit center at best, and as an economic hinterland at worst.

Ultimately, the contrast between locally owned banks and out-of-state–owned banks comes down to a question of the values we believe Albuquerque's economy should serve. Should it give priority to out-of-state financial interests or to the financial well-being of our community and state? For Albuquerque to support the capacity for innovation our local brain power is capable of, we need to start keeping our money circulating in the local economy. As residents we can exercise our rights as bank customers by choosing to do our business with those banking institutions that are locally owned and therefore have a long-term interest in Albuquerque's future.

CENTRAL'S FATE
Mark C. Childs

1998 The Spanish founded Albuquerque at the crossroads of the Camino Real and an ancient trail through Tijeras Canyon. In 1858, a decade after the Treaty of Guadalupe Hidalgo—an outcome of the Mexican-American War that ceded New Mexico to the United States—US Army Captain Randolph B. Marcy led the rebuilding of Carnué (Tijeras) Canyon Road into part of a transcontinental wagon route, Marcy's Road. This transformation of the road to accommodate a new type of transportation heralded the beginning of a series of reconstructions of the road and Albuquerque.

In 1880 the railroad established a station two miles to the east of Old Town. Railroad Avenue was platted and graded over the local portion of Marcy's Road to connect the depot to Albuquerque and to aid the creation of a new Albuquerque along its boardwalks.

For ten cents, one could ride mule-drawn streetcars along Railroad Avenue (see the 1898 photograph) from the railroad depot in New Town to the plaza in Old Town. However, horses, bicycle, and shoe leather were the main means of transportation.

Twenty-four years later the mules were retired in favor of electric streetcars. These new vehicles connected not only Old Town but also new residential districts such as Huning Highlands to Railroad Avenue, and they ushered in another rechristening of the street.

On May 21, 1907, the *Albuquerque Morning Journal* reported, "It is the consensus of opinion that the name Railroad Avenue was misleading and inappropriate and in the opinion of some it has been a real detriment to the interests of the business men and property owners along that thoroughfare. The name 'Central Avenue,' it is believed, will at once convey the idea that it is the city's main business street and center of town." In another two decades, the street gave way to the automobile. In 1928 the twelve remaining streetcars were converted to motel rooms at Napoleon's Deluxe

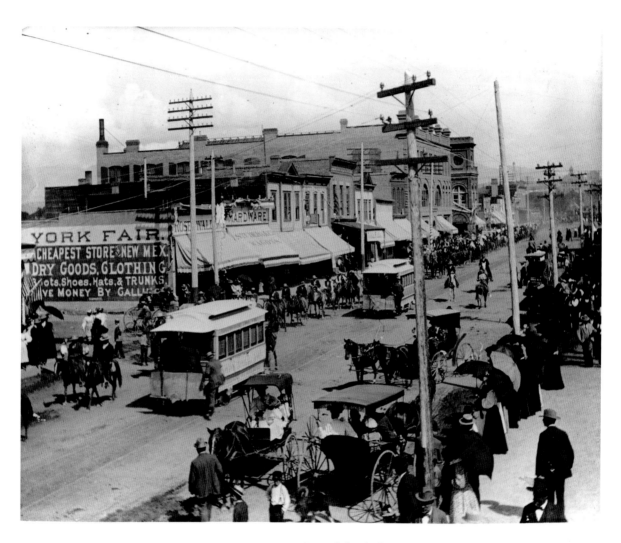

1898. A parade heads down Railroad Avenue, later renamed Central Avenue, in this view looking east at Railroad from Third Street. Courtesy of the Albuquerque Museum, Gift of Marietta Voorhees, 1971.061.001.

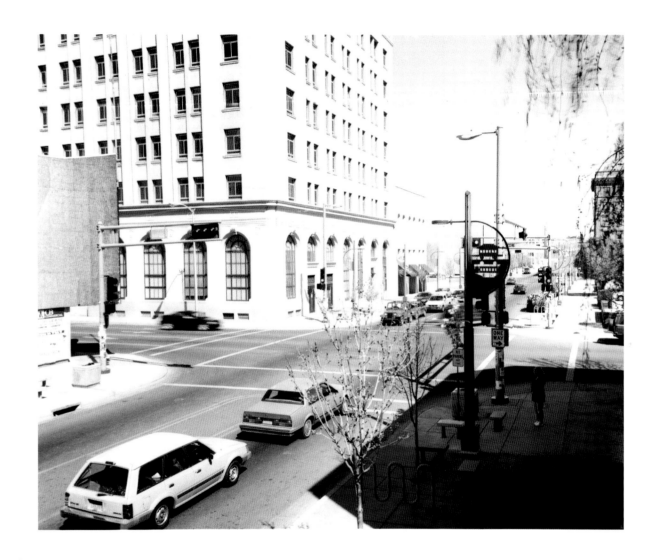

1998. A century later virtually everything changed in this identical view, including the means of transportation and the name of the street. Photograph by Krista Elrick.

Service Station and Auto Camp, and in 1937 Central Avenue began its run as Route 66.

Just as the Spanish settlement of Albuquerque had its own urban pattern and architecture, and the new railroad town of Albuquerque had its midwestern Victorian main street, the heyday of the automobile produced the drive-in strip and Streamline Moderne architecture.

The freeway era ended the reign of Route 66 in the 1960s. Urban renewal cleared the way for downtown parking lots. In direct mimicry of the evident success of Winrock and other malls, plans were made to turn downtown Central Avenue into a pedestrian mall. Central's traffic was planned to be diverted into Copper and Gold Avenues.

The architecture of the 1960s and '70s Age of Aquarius is just getting old enough and safely disconnected enough from our present economy to garner historic interest. However, the street-spanning, solar-conscious Public Service Company of New Mexico Building was built near the end of the wave (1980) and provides a good example of the period.

In 1984 a special study of what to do with the "decaying" Central Avenue area developed the concept of "the cultural corridor." The idea was to emphasize the congregation of cultural and historical assets that line Central Avenue and to make Central once again "the place to be."

Turn of the millennium projects such as downtown sidewalk improvements, the reuse of Albuquerque High, the Alvarado transit center, and the downtown movie theater complex were all in line with the cultural corridor strategy. The architecture of this era is still in active debate but clearly involves taking stock of our various legacies.

Central Avenue has been reformed on a roughly twenty-year cycle of change. The story of Central will continue to be retold. The question is, what chapter do we want to write next?

2017 In 2016 the Albuquerque Rapid Transit (ART) project began remodeling Central Avenue to provide dedicated bus lanes from Ninety-Eighth Street to Tramway Boulevard. Proposed by Mayor Richard Berry and vigorously opposed by numerous groups, ART will write the next chapter of Central's history.

The design of the bus lanes and transit stations is complicated by changing street right-of-way widths with some narrow sections and a primarily center transit lane design. More fundamentally, two questions were, in my observations, never robustly addressed:

1. Why was rapid transit a higher priority than frequent, reliable, widely connected, and perhaps even convivial transit? Re-creating a system akin to the historic trolley network may have been more effective in terms of economic development, transit ridership, and long-term city improvement as it has been in many other US cities.

2. How could the public and affected citizens and businesses be substantive partners in the details of the design? While engaging with multiple stakeholders with multiple agendas is never easy, and it may not be possible to please all parties, ART appears to have suffered from a "get-it-done" as opposed to "make-it-great" approach.

Assuming that the project is completed as designed, the next mayor and councilmembers will be left to manage and add to the street. While this redesign will improve the sidewalks of Central Avenue in many places, I don't believe it will add up to a great street (I hope I am proved wrong). For ART to succeed in invigorating the life of the street, I suggest that the next mayor initiate a second wave of substantial and well-considered pedestrian, bicycle, and character improvements not only to Central but also to connecting streets.

Central Avenue needs to become a place people will stroll, will sit and have a coffee, and will go to because things are happening there. It needs to be easy and pleasant to walk or bicycle to the transit stops during the summer heat, the monsoons, and on crisp winter days. It needs to be a place that toddlers can safely toddle, where neighborhoods want to hold parades, a place that tourists come to photograph, and, perhaps, people will once again write songs about. We need to do the long, hard, inspired, and sometimes expensive work to make Central great.

The question remains: What chapter do we want to write next?

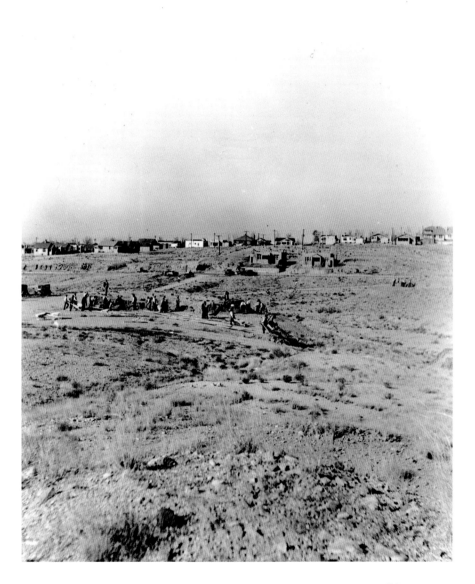

1935. Crews begin construction of Roosevelt Park in this view looking north toward the southwest corner of Coal Avenue and Sycamore Street. Courtesy of the Albuquerque Museum, Albuquerque Progress Collection, Gift of Albuquerque National Bank, 1983.001.601.

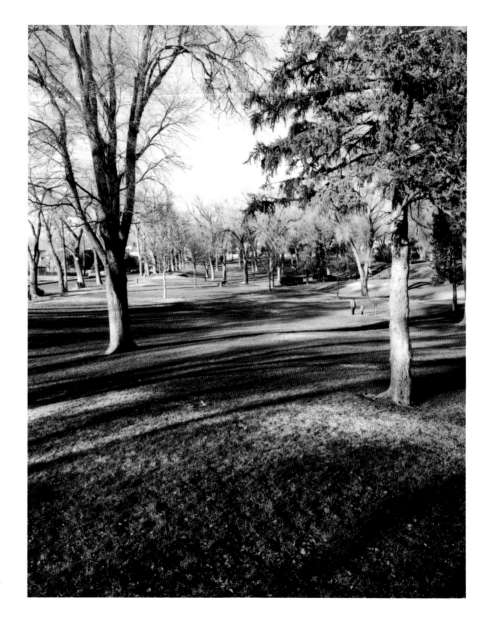

1998. The same view of Roosevelt Park. Note the land bridge that crosses the arroyo in the upper third of each photograph and the two houses set into the hill forming the northern bank of the arroyo in the 1935 photograph that are barely visible through the trees in this 1998 photograph. Photograph by Krista Elrick.

HOW PARKS PAY
Anthony Anella

1998 In 1919 the landscape architect Frederick Law Olmsted Jr. (as cited in Weiss 1987, 60) observed that "a local park adds more to the value of the remaining land in the residential area which it serves than the value of the land withdrawn to create it." This enhancement value of open space influenced the thinking of Mayor Clyde Tingley who, in 1933, persuaded George Hammond, the developer of the Terrace Addition, to donate a block of his land for a park. Tingley then secured a long-term lease on land owned by the Albuquerque Public Schools to create a fourteen-acre parcel. First named Terrace Park, Roosevelt Park is located on land that was difficult to develop: it is situated along an arroyo, and part of it had been a dump.

In addition to enhancing the value of the residential neighborhood (as well as the value of his own home located not far from the park on Silver), the idea of constructing a park near Albuquerque's growing eastern suburbs also appealed to Mayor Tingley as a way of creating jobs in Albuquerque during the Great Depression. Over 90 percent of the development costs for the park were paid by the Federal Emergency Relief Administration (FERA). By law, FERA could only pay for the cost of labor. Within months of starting construction, crews of up to three hundred men moved from basic grading and leveling to building retaining walls, stone steps, and walkways; installing a sprinkler system; and planting lawns, trees, and shrubs.

Originally the land was covered with "snakeweed" and arid-region grasses. Under the supervision of pioneer New Mexico landscape architect C. E. "Bud" Hollied, it was transformed into a green oasis. A comparison of the historic and contemporary photographs reveals how ambitious the transformation was. The only evidence that we are looking at the same place consists of the general topography (including the land bridge that crosses the arroyo in the upper left third of each photograph) and the two houses set into the

26

hill forming the northern bank of the arroyo (barely visible through the trees in the contemporary photo).

The predominant trees in the park are Siberian elms. Now over sixty years old and towering sixty to eighty feet high, they form the park's canopy. Other vegetation includes Rocky Mountain juniper, blue spruce, catalpa, and two kinds of juniper shrubs. The lawn consists of Kentucky bluegrass mixed with dandelion and clover. Roosevelt Park exemplifies the "frontier pastoral park"—a naturalistic composition of random trees and rolling hills—favored by New Deal landscape projects in New Mexico. For this reason and others it is on the National Register of Historic Places. It is also the only park in Albuquerque to be designated an historic landmark.

Olmsted's observation is substantiated by several empirical studies measuring the enhancement value of open space that are cited by Charles J. Fausold and Robert J. Lilieholm in "The Economic Value of Open Space: A Review and Synthesis." For example, a 1967 study of a ten-acre neighborhood park in Lubbock, Texas, found that "within a two-and-one-half block area around the park, land values declined with distance from the park" (Fausold and Lilieholm 1996, 8). This relationship was true for the sales price of land only—not houses and land—a fact with revealing implications for land developers.

In Boulder, Colorado, a 1978 study found that "the existence of greenbelts had a significant impact on adjacent residential property values. While controlling for other variables, they found properties adjacent to greenbelts in the three neighborhoods studied to be worth an average of 32% more than those 3,200 walking feet away. The relationship was linear: a $4.20 decrease in the price of residential property for each foot away from the green belt. In one of the neighborhoods the aggregate property value was approximately $5.4 million greater than it would have been without the greenbelt, resulting in a potential additional annual neighborhood property tax revenue of $500,000" (Fausold and Lilieholm 1996, 8–9).

These empirical studies quantify the fiscal and economic implications of open space preservation. They demonstrate that, as Olmsted observed, open space does affect the surrounding land market in positive ways—both for the individual property owners as well as for the local governments that depend on property tax for operating revenue. Unfortunately, the reverse is also true. Poor planning can cancel the enhancement value of open space. In 1950 the city changed Lead and Coal Avenues from two-way streets into one-way arterials. In the vicinity of Roosevelt Park, traffic increased along with a corresponding decrease in the desirability of the neighborhood as a place to live. Property values plummeted, and absentee landlords filled the void left by departing residents. The economic implications of open space preservation and other quality of life issues prompt a reassessment of the conventional wisdom about the consequences of development and conservation. When thoughtfully designed to be integrated into a neighborhood, open space preservation contributes not only to the intangible

value of making Albuquerque a more enjoyable place to live but also to the economic bottom line.

2017 *We have been half persuaded by Thoreau and by the evidence of our own brutal use of the land that the earth is beautiful except where man lives, or has passed through; and we have therefore set aside preserves where nature, other than man, might survive, and which men may visit in reasonable numbers and with adequate supervision, for their education and edification. This is an imaginative and admirable idea, and would perhaps be nobler still if we locked the gates to these preserves and denied ourselves entrance, so that we could imagine better what transpires there. We could then turn our attention to the rest of the earth, the part in which we live, which is not yet devoid of life and beauty, and which we might still rescue as a place worth celebrating.*

—John Szarkowski, American Landscapes

Albuquerque is worth celebrating.

More than any other city in the United States, Albuquerque has preserved open space. We are first on the list of cities to have set aside open land for our children and our children's children to explore and enjoy. Twenty-nine thousand acres of it to be precise. Twenty-nine thousand acres of openness in which to let loose our souls! Twenty-nine thousand acres of wildness for future generations to experience nature firsthand in direct, unmediated contact,

so they might not lose the sense of wonder and exhilaration that inspires the best in us—as artists, as scientists, as people of faith and hope, and as citizens of our community and of the larger world.

Albuquerque is worth celebrating.

Open space is one of the best quality of life advantages Albuquerque has going for it as it attempts to keep and to attract the next generation of creative innovators: the young people who—by virtue of their creativity—can choose wherever they want to live and work; the young people looking to raise their families in desirable places. Open space helps define Albuquerque as a desirable place to make a life and earn a living. In this regard, our open space is a self-sustaining engine of economic growth. Quality of life matters.

Open space is what differentiates our city from its regional neighbors. Think Phoenix and images of freeways and concrete-lined canals come to mind. Hot enough to fry an egg on a sidewalk and unlivable if not for diverted Colorado River water. Think Denver and images of the Rockies and opportunities for an active outdoor lifestyle come to mind. Never mind how choked with cars I-70 becomes as weekenders head out of town for the mountains. Humans have a bad habit of ruining paradise. Think Albuquerque and images of the Sandia Mountains, the volcanoes, and the green ribbon of Rio Grande fertility come to mind. Few American cities can boast such magnificent natural amenities. Albuquerque is defined by its spectacular natural landscape. It is also defined by a noble history of enlightened

citizen activists protecting that natural beauty as open space. This may be what differentiates Albuquerque most of all.

The vision Aldo Leopold had for creating a park along the length of the Rio Grande when he served as the first secretary of the Albuquerque Chamber of Commerce from 1918–1919 finally resulted in the Rio Grande City Park, which includes our world-class zoo and the Rio Grande Valley State Park, a twenty-two-mile-long continuous swath of riverside habitat through the heart of Albuquerque created by the state legislature in 1983. The purpose of the legislation is "the preservation, protection, and maintenance of the natural and scenic beauty of a designated portion of the Rio Grande and its immediate corridor"—forever. In 1993 Albuquerque's city council strengthened the state's legislation by adopting the Bosque Action Plan, which established policies to ensure the conservation of the bosque in its natural state and marked the beginning of a larger effort to protect open space in Albuquerque.

Open space helps Albuquerque stay connected to its history and cultural heritage. The petroglyphs are an example of this. Petroglyph National Monument, managed by a partnership between the National Park Service and the City of Albuquerque, protects one of North America's largest petroglyph sites. It contains thousands of ancient designs and symbols carved onto the volcanic rock by the ancestral Pueblo Indians. They are part of Albuquerque's ancient cultural heritage, a tangible expression of the grand cultural continuum that gives Albuquerque its soul.

The Rio Grande is another example of this. Albuquerque would not exist without it. The river's precious lifeblood was first diverted in prehistoric times when early Pueblo farmers depended on it for growing corn. Spanish colonists, applying lessons learned from the Moors, expanded the network of Pueblo ditches to spread the water onto their fields. *Acequia*, the Spanish word for "irrigation canal," derives from *as-saquiya*, the Arabic word for "water carrier." Even today the deep wells that tap the underground aquifer, making settlement of the uplands on either side of the valley possible, are inextricably tied to the river. Known to the Pueblo Indians as P'osoge and to the Spanish as Rio Bravo del Norte, the Rio Grande has no rival for historical richness among the rivers of North America. This historical richness is one of Albuquerque's greatest assets. History comes alive when it is understood in the context of its environment. Open space provides that context. By fostering a shared sense of place that is part of our collective identity and community spirit, open space reminds us of who we are as citizens.

Open space helps people stay connected to the land. This is especially important for our young people. Today, as a result of Albuquerque's rapidly increasing population and the corresponding loss of farmland, fewer and fewer young people share a connection to the land. As Richard Louv (2008, 3) writes,

The postmodern notion that reality is only a construct—that we are what we program—suggests

limitless human possibilities; but as the young spend less and less of their lives in natural surroundings, their senses narrow, physiologically and psychologically, and this reduces the richness of human experience. . . . Reducing that deficit—healing the broken bond between our young and nature—is in our self-interest, not only because aesthetics or justice demands it, but also because our mental, physical, and spiritual health depends on it. The health of the earth is at stake as well. How the young respond to nature, and how they raise their own children, will shape the configurations and conditions of our cities, homes—our daily lives.

Albuquerque's open space provides an opportunity to heal the bond between our young and nature. Unlike most cities where nature is under assault, it is still possible to see herons, cranes, and even bald eagles in the Rio Grande bosque that runs through the heart of Albuquerque, and it is still possible to see mule deer, black bears, and mountain lions in the Elena Gallegos Open Space in the foothills of the Sandia Mountains. Many cities have to invest millions of dollars to re-create greenbelts. In Albuquerque all we have to do is protect what we, as the fortunate beneficiaries of past foresight, already have.

According to David Parsons (pers. comm.), retired career wildlife biologist for the US Fish and Wildlife Service, "A leading cause of biodiversity decline is habitat destruction and fragmentation. As suitable habitats decline and remaining pieces get smaller, nature suffers. Reestablishing connectivity among patches of wild nature is a major goal of modern conservation biology theory and practice." To provide appropriate scientific oversight, and to ensure that the management of Albuquerque's open space is compatible with conservation science, a technical advisory group with expertise relating to conservation biology and restoration ecology needs to be established. Protecting and restoring the ecological health of Albuquerque's open space should be the top priority of any open space plan.

Roger G. Kennedy, a past director of the National Park Service, writes, "The land is where we live and where the consequences of our presence accumulate, determining what else we can do, and what we can no longer do. The land is thus the book of our lives. Each day we write upon it new pages, some splendid, some sordid, informing our progeny of the truth about us whatever we may write elsewhere" (2003, 1). Albuquerque's open space tells our children that, for all of our other foibles and shortcomings, we were inspired by the beauty of this place to protect it for them.

Albuquerque is worth celebrating.

MAKING A CIVIC SPLASH
Mark C. Childs

1998 Places made specifically for joy are among the greatest achievements of cities. Tingley Beach, also known as Ernie Pyle Beach, Conservancy Beach, and Municipal Beach, was one place made for public fun. In its original heyday during the '30s and '40s, the beach was the place to swim, boat, fish, picnic, and flirt. There were even, for a time, motorboat races.

Tingley Beach was named after Clyde Tingley, who as chairman of the city commission was instrumental in creating the swimming hole. Tingley persuaded the Middle Rio Grande Conservancy District (MRGCD) to construct the basin and provide water.

The MRGCD was created in 1923 to take over the older system of acequias (irrigation ditches) and mayordomos (locally elected ditch officials) in the valley and provide a coordinated set of irrigation ditches and flood control devices. Because of lawsuits and other delays, the MRGCD

projects were just beginning when the Depression hit. Thus, the conservancy's work provided employment and helped buffer New Mexico from the first years of the Depression. Nevertheless, times were tough, and Tingley asked for volunteer labor to build the bathhouse and changing rooms for the beach.

Tingley Beach was constructed in 1930 and 1931 before the federal New Deal agencies such as the Works Progress Administration were created. However, the beach was very much in the spirit of New Deal projects. It was funded by a special government agency, it employed a large amount of skilled labor, and it created a place for the public to enjoy.

Clyde Tingley became a friend of Franklin D. Roosevelt, and during Tingley's tenure as governor of New Mexico, he worked with FDR to secure a number of New Deal projects in the state, particularly in Albuquerque. The Central Avenue railroad underpass, the Albuquerque Little Theatre,

1934. Swimmers enjoy a day at the newly created Tingley Beach in the view looking west. Courtesy of the Albuquerque Museum, Brooks Studio Collection, 1978.152.209.

1998. In this same view islands have replaced the swimming raft—and other recreational uses have replaced swimming. Photograph by Krista Elrick.

2017. *Fish Globe* by Colette Hosmer, 2007. Steel. Photograph by Mark C. Childs.

sidewalks in Nob Hill, numerous neighborhood parks, and extensive work at the University of New Mexico were some of the fruits of this collaboration.

Of all of these projects, however, Tingley Beach may be one of the best examples of the political genius embodied in Depression-era public works projects. It not only employed people but gave them an inexpensive place to have fun as a community. Children, teenagers, and employed and unemployed adults shared the beach. All ages share the raft in the 1934 photo. Kids could be kids *and* part of society.

Sharing fun in public may be essential to civilization.

In the 1990s the police department in Flagstaff, Arizona, sponsored skateboard and stunt-bike rallies in a downtown municipal parking lot. The police found that legitimizing teenagers' activities in public significantly reduced juvenile crime. Planners in the lively cities of Seattle and Portland suggest that one of the most effective ways to induce people to live downtown and decrease sprawl is to make cities fun.

Places made for public fun are also economic assets to a city. The July 1936 cover article of *Albuquerque Progress* discussed the economic benefit to Albuquerque of the beach as a tourist attraction. Today, the aquarium and botanical garden that sit just north of Tingley Beach draw tourists and increase the city's appeal to migrating businesses and executives.

When I wrote the first version of this article for the *Albuquerque Tribune*, Tingley Beach was a duck pond. During

the 1950s public swimming places were identified as possible sources of polio, and Tingley's bathhouse and marina were torn down. In 1952 the lagoon was reduced in size to make room for the construction of the Central Avenue Bridge. In the 1970s concerns that fish might be infected with botulism forced frequent closures of the beach. At the end of the twentieth century Tingley Beach was a place to jog past, watch the ducks, and perhaps have a picnic. The joyful splashes of swimmers were gone.

Yet the spirit of the swimming hole lived on. Various revivals and reconstructions were attempted beginning in the 1950s. The Albuquerque BioPark, with its zoo, aquarium, and botanical gardens, is a descendent of the public investment made in the swimming hole. These places are good for the economy, educational, elegant, and fun. However, I wonder if their admission fees detract from their accessibility and if they could be more attractive to teenagers.

2017

Success! The Association of Zoos and Aquariums awarded the renovated Tingley Beach the 2008 North American Conservation Award. This was the result of a long-concentered effort. After a series of discussions and legal proceedings in the mid-1990s, the city acquired the property from the Middle Rio Grande Conservancy District. The redevelopment of ponds could then begin.

Tingley Beach was thoroughly renovated starting in 2004 and was reopened to the public in November 2005. The renovated beach does not include swimming facilities but does include pedal boat rentals, a catch-and-release fishing lake, a model boat pond, a children's pond, and Tingley Station with restaurants, arcade games, bike rentals, and restrooms.

The renovation also includes a robust set of public art pieces including Betty's Sabo's *Clyde and Carrie Tingley*, *Corazon* by Patrick Simpson, and *Gar Bender* by Joe Barrington. The towers of Ed Haddaway's *Bosque de los Sueños* add a sense of whimsy to the park. My favorite artwork of the original set is *Fish Globe* by Colette Hosmer. The twelve-foot-tall rusted steel *Fish Globe* is made of six hundred interlocking Rio Grande cutthroat trout fish cutouts and evokes the sense of a giant beach ball in the sand. The shadows of the fish cutouts give the globe a different character over the course of a day. The piece manages to be thoughtful and playful, which can also be said of the redesign of Tingley Beach as a whole.

On any given day at Tingley Beach, one can see families picnicking, old and young people fishing, kids playing on pedal boats, and joggers and bike riders passing by. In 2017 Tingley Beach is once again a public place made for fun.

REMEMBER THE ALAMO
Anthony Anella

1998 Aldo Leopold, a man destined to become one of America's and one of the world's most important conservationists, served as the first secretary of the Albuquerque Chamber of Commerce from 1918–1919. One of his pet projects was to create a park along the length of the Rio Grande that would be one of Albuquerque's "greatest assets." In a 1918 issue of *Forward Albuquerque*, the chamber's quarterly bulletin, Leopold wrote, "Every landowner should remember that the City, in asking for the donation of the necessary lands is not asking charity of its citizens. It is offering a business proposition which every thoughtful man knows to be for the mutual benefit of all concerned. . . . It will be the largest City park between Denver and the coast. It offers the finest scenery and views to be found in the valley." Leopold's vision resulted in the Rio Grande City Park, which includes our world-class zoo and the Rio Grande Valley State Park.

Today, there is a growing awareness among business leaders that a community's quality of life is one of its chief economic assets. New businesses choose to locate or expand in locales that offer enjoyable places in which to live. Communities that have allowed their natural amenities to be degraded suffer a competitive disadvantage when trying to attract new employers. As Leopold observed, it is in the *entire* community's interest to protect these special places.

Leopold's insight was lost in the political rhetoric that pitted the West Side against the North Valley in the final two years of the Montaño Bridge debate. For former Mayor Martin Chávez, the issue was simple and fatalistic: "I think most Albuquerqueans and most residents of the Village understand that when you're confronted with the future, you can either get on board or stand in front of it and get run over. . . . I'm getting my City on board" (Hartranft 1995). His view resonated with the widespread frustration of Albuquerque citizens living on the west side of the Rio Grande who experienced long waits in traffic when crossing the river.

Never mind that, as predicted, the Montaño Bridge has not solved the West Side's transportation problems and has only made other parts of the city's transportation problems worse. The bridge is a magnet for traffic. Coors Boulevard now carries several thousand more cars per day than it did before the bridge opened. And on the east side, the intersection at Fourth Street and Montaño has become a bottleneck with waits as long as twenty minutes during rush hour thanks to the poorly conceived project. Rather than seeking the win-win of comprehensive planning, former Mayor Chávez and other elected officials settled for a $30 million quick fix and ended up with a lose-lose.

What we lost was part of one of those places that makes Albuquerque distinctly attractive as a place to live and as a place to visit. A 1987 Presidential Commission found that natural beauty is the single most important factor in choosing a tourist destination. The bosque makes an authentic contribution to Albuquerque's natural beauty. Tourism makes up 7 percent of global trade in goods and services and $195 billion per year in domestic and international receipts. Is it really prudent for Albuquerque to forsake its share of those receipts by degrading those places that make it attractive as a tourist destination?

The bosque is a precious natural resource for *all* residents of our community. It is also an invaluable economic asset as an attraction to both new business and tourism. Preserving and protecting what remains of the bosque should become one of Albuquerque's top priorities.

Aldo Leopold's lifelong philosophical search for how man could live on the land without spoiling it culminated in his land ethic: "A thing is right when it tends to preserve the integrity, stability and beauty of the biotic community. It is wrong when it tends otherwise." The image of the Montaño cottonwood as a symbol of community spirit organized around such a land ethic must not be forgotten. Too much is at stake. Unless we protect places like the bosque, we will have betrayed the beauty of those places for an anonymous future. If they are crisscrossed by freeways, then Albuquerque will become just another Phoenix. May the image of the Montaño cottonwood remind our elected officials of their responsibility to engage the electorate in a more comprehensive approach to planning our community. May its memory remind us that progress is an empty concept unless it is based on a fundamental respect for quality of life.

2017

As I noted in 1998, Mayor Martin Chávez's simplistic and fatalistic view of the Montaño Bridge debate resonated with widespread frustration concerning transportation in our city. It also failed to articulate a long-term vision. This is the crux of the problem.

Nature doesn't work in the short increments of time that preoccupy our political leaders. It took the Montaño cottonwood over a hundred years to grow to its impressive circumference. It only took Mayor Chávez one night (under cover of darkness) to demonstrate his political decisiveness by having it cut down. A disconnect, if not a conflict, exists

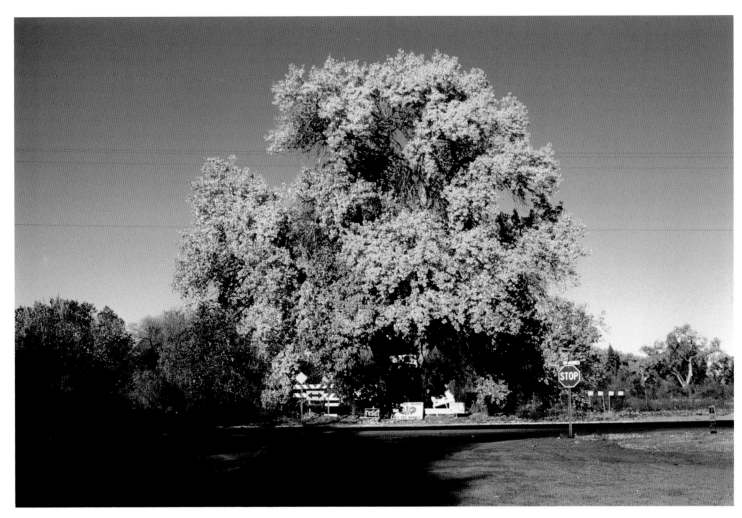

1995. Looking west toward the intersection of Montaño Road and Rio Grande Boulevard, a large cottonwood tree (*álamo* in Spanish) dominates the view. Known among residents as "the big tree," it was cut down two months after this photograph was taken to make way for the Montaño Bridge. Photograph by Anthony Anella.

1998. The same view taken a year after the bridge was completed.
Photograph by Anthony Anella.

between how our political system works and how our planet works. This disconnect is not just because human time is dwarfed by geologic time (the average human life span is the width of a hair compared with the Earth's 4.5-billion-year history). It also has to do with how we elect our representatives. Because elected officials serve relatively short terms in office (four years for mayor and governor), their vision is confined to the horizon of the next election. No wonder they barely have time to focus on the short term rather than on what society needs over the long term. The thinking of our elected representatives is restricted to what can be accomplished in their short time in office because the success of their next campaign for reelection depends on it—in spite of what might be better for the long-term environmental health and quality of life in our community. Short-term political expedience trumps long-term vision.

This fact is made worse by the amount of money it takes to campaign for political office. As soon as our representatives are elected, they need to start fund-raising for their next election. This leaves precious little time for them to focus on the complex challenge of governing by listening to all their constituents. They are forced to narrow their focus on the needs and desires of the constituents who can most afford to finance their political ambitions.

Witness the tenure of Richard Berry as mayor of Albuquerque. At the beginning of his first term, to paraphrase Mayor Berry, he asked, "What do we want Albuquerque to be fifty years from now?" To help answer this visionary question, Mayor Berry proposed "ABQ: The Plan," an enlightened attempt to govern by focusing the public's attention on the long-term needs of our community. But then the reality of the next election cycle forced him to rush things. The way Mayor Berry has handled the implementation of a trail system through the Rio Grande bosque is a tragic example of short-term expedience trumping long-term vision.

On September 4, 2013, Mayor Berry had his design consultants unveil his plans for the bosque trail at the Albuquerque Museum. More than four hundred citizens showed up. The overwhelming majority opposed not just the plans but the process that created the plans. In his rush to complete his "Rio Grande Vision" so he could add it to his political resume, the mayor failed to insist that ecological science inform his consultants' design. This would have taken too long. As a result, the design lacked meaningful substance. What the mayor's consultants presented was marketing eyewash. The people who attended the meeting saw through the marketing. They didn't buy it. The city canceled a second meeting scheduled for September 18, presumably to shield the mayor from controversy before the upcoming mayoral election in October. The people showed up anyway. Because it was no longer an "official" city meeting, the Albuquerque Museum was not open. About 250 people met outside the museum.

They did not oppose building a trail in the bosque but wanted a design based on ecological science. They understood that providing better access to the bosque would lead to more people caring about the bosque, and if more

people cared about the bosque, there would be more voters to protect it. They especially wanted more schoolchildren to have access to the bosque. They also understood something Mayor Berry and his design consultants did not: the design of the trail needed to be based on ecological science so that what made the bosque such a special place to visit would be protected over the long term. As a result of the meeting, Sierra Club representatives and other concerned citizens formed the "Bosque Action Team" to monitor the bosque trail project.

During the first half of 2014, after Mayor Berry won reelection, the city conducted a series of "Bosque Educational Forums." This was a hopeful sign that perhaps the mayor had heard the citizens' concerns. However, it was never made clear how the information gathered in these forums would be used to influence the design work that had already been completed by the mayor's consultants. As it turned out, the forums did not influence the design of the bosque trail because the mayor's consultants and the city officials only went through the motions of civic engagement.

On February 9, 2015, the city began bulldozing a trail through the bosque between Central Avenue and Interstate 40. This angered the representatives of the Sierra Club and Bosque Action Team who believed the city had reneged on its promise to allow the public to review and comment on the design of the bosque trail before a final plan was selected and construction started. The design of the bulldozed trail was not informed by ecological science as the representatives of the Sierra Club and Bosque Action had wanted. It did not take into account issues such as proximity of the trail to the riverbank where prime wildlife habitat was located or how to route the trail in order to protect denning and nesting areas as well as foraging and hunting areas.

In response to this violation, the Sierra Club and Bosque Action Team sought an agreement with the city that would define how future work in the bosque would take place. On March 25, 2015, a "Future Bosque Work Agreement" was reached with Mayor Berry's administration "establishing procedures for implementing improvements and expending funds within the Rio Grande Valley State Park by the City of Albuquerque." In testimony he gave at the city council meeting on April 6, 2015, Michael J. Riordan, Mayor Berry's chief operations officer, confirmed that the agreement had been reached, stating, "We worked out a process to move forward with the [bosque trail] project as far as public involvement, as far as environmental review, and as far as public notification of when construction will start. . . . There will no discrepancies about when it starts and what kind of trail it will be" (City of Albuquerque 2015).

At the same meeting on April 6, 2015, Councilors Isaac Benton and Ken Sánchez introduced Council Bill Number R-15-171 to the city council to formalize the "Future Bosque Work Agreement." The council postponed voting on the bill. On November 16, 2015, after months of postponements and making two floor substitutes of the bill, the city council voted 5–4 to approve the bill. The mayor

vetoed the final bill even though it contained word for word what his administration had agreed to at the meeting on March 25, 2015. At their meeting on December 9, 2015, the city council was unable to override the mayor's veto. Mayor Berry decided not to abide by the agreement. He directed the work to extend the bosque trail from Interstate 40 to Campbell Road to proceed in early 2016. The excuse Mayor Berry gave for not honoring the agreement he had made was the urgency of completing the trail before the spring 2016 nesting season.

This justification was bogus. The fact is, Mayor Berry could have just as easily postponed the trail construction until after the spring 2016 nesting season and begun the work in the fall of 2016. In his rush to complete his Rio Grande Vision to serve his own political needs, the mayor trampled on not only the bosque but also the public's trust in government. Mayor Berry refused to engage the citizens in a meaningful dialogue for how to make his Rio Grande Vision better. Rather than respect the fact that so many citizens of Albuquerque cared deeply about the bosque as a special place in the community by listening to their concerns, he chose to ignore them. Adding insult to injury, he used a bogus excuse for justifying his actions.

The wise carpenter knows to measure twice and cut once. In the case of Mayor Berry's development of the Rio Grande bosque, the mayor did not take the time to measure what we have in the bosque nor what we stand to lose by cutting into it. Nor did the mayor take the time to measure what Albuquerque's citizens want done with the bosque. The mayor felt compelled to rush the job. He subordinated taking the time necessary to do the job right to his own political ambitions.

In an age distinguished by short attention spans, simplistic sound bites, social media, and political apathy, it is remarkable how persistent the citizens fighting to protect the bosque have been. Civic engagement is one of any city's most precious resources—especially in a democracy that depends on an active and engaged electorate to function. By putting his political ambitions ahead of civic engagement, Mayor Berry failed as a leader. He trampled on the public's trust in representative government and bet the voters wouldn't remember.

What Mayor Berry's cynicism and Mayor Chávez's fatalism have in common is the short increments of time that preoccupy our elected representatives. Because they serve such short terms in office and because they are forced to raise so much money to campaign, our elected representatives too often make short-term decisions at the expense of our long-term well-being. One solution to this dilemma may be to change the time our elected representatives serve to a longer term in office. Another solution may be to enact campaign finance reform so our elected representatives have more time to focus on the long-term ecologic and economic well-being that would make a real contribution to Albuquerque's quality of life—for the sake of our children and grandchildren.

WHEN DOWNTOWN DELIVERED
Mark C. Childs

1998 Just as many species of trees benefit from being part of a forest, species of buildings can benefit from being concentrated in a district. Wall Street, Hollywood, and Santa Fe's Canyon Road illustrate the synergy of a district. Downtown Albuquerque once benefited from a "Federal District."

Congress passed its first omnibus public buildings law in 1902 to erect post offices throughout the nation. Albuquerque's slice of this turn-of-the-century pie was the 1908 post office building on Fourth Street and Gold Avenue. This is the oldest remaining federally built building in Albuquerque, and it heralded the influx of federal institutions that later gained Albuquerque the nickname "Little Washington."

Indeed, the 1908 post office was sited and designed to strongly express the presence of the federal government and to establish Albuquerque as a satellite "seat of the government."

The site for the post office, on the northwest corner of Fourth and Gold, was prime available property in 1908 Albuquerque. The Alvarado Hotel and train station capped the east end of Gold, and the movers-and-shakers Commercial Club anchored Gold and Fifth. Gold was the civic and financial street of the city with banks, lawyers' offices, newspapers, and upscale businesses lining the way between the Alvarado and the Commercial Club. Fourth Street was emerging as the north-south road connecting Albuquerque to the nation. In 1910, two years after Ford introduced the Model-T, Fourth was designated as NM Route 1.

The Beaux-Arts style of the post office was chosen by the federal government's supervising architect, James Knox Taylor, to differentiate from commercial structures, associate it with the classicism of previous federal buildings, and lend it the dignity of a place of government.

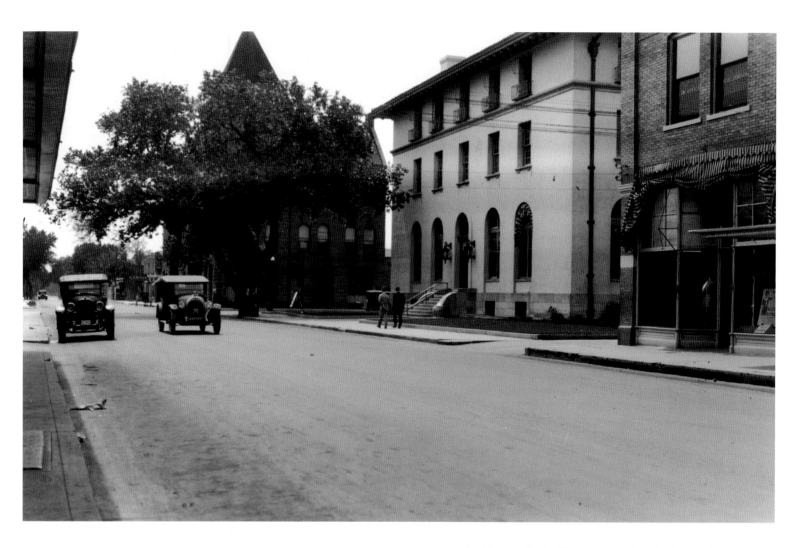

1925. Looking south, the Beaux-Arts–style federal post office was one of the landmarks that briefly earned downtown Albuquerque the nickname "Little Washington." Courtesy of the Albuquerque Museum, Wards Hicks Collection, 1982.180.489.

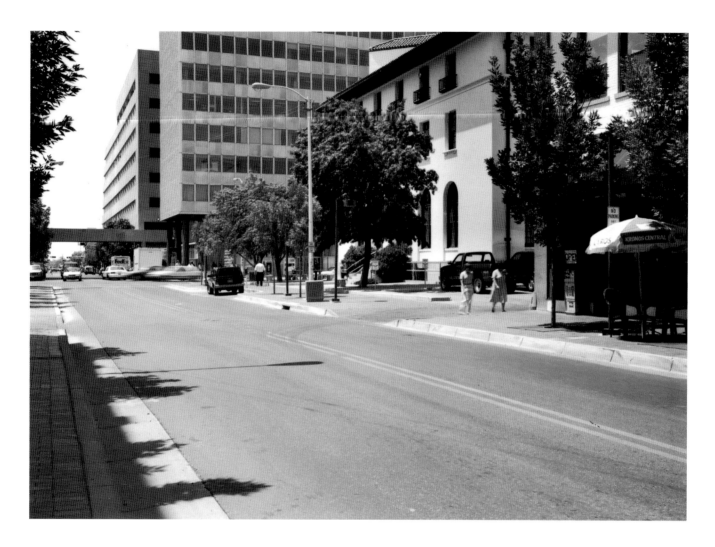

1999. The post office building is the oldest remaining federal building in Albuquerque—and in 1999 it still housed a variety of federal agencies. In 2017 the Amy Biehl Charter High School inhabits the building. Photograph by Krista Elrick.

In 1908 railroad-Victorian–style buildings nestled up to the boardwalk along Gold, and many provided awnings over the boardwalk. The post office sat on a half-story basement pedestal and was set back from Gold and Fourth to provide public forecourts. The entrance stairs in these forecourts provided dramatic stage sets along the streets.

In the late 1920s an addition was built to the west along Gold Avenue, and in 1930 a new Pueblo Deco–style federal building was added, completing the first federal block along Gold and establishing a federal district, or Little Washington.

This concentrated district induced lawyers, consulting engineers, and others with government business to locate downtown. Newspaper offices, for example, were where the action was. Federal and private employees, in turn, supported local cafés and shops.

This intermeshed set of uses supported public transit and allowed people to walk to meetings, to lunch, and even to a store on the way home. Moreover, Albuquerque's downtown provided a civic focus. Parades, election rallies, and protests naturally centered there.

By the 1980s the federal government no longer wished to differentiate its buildings from commercial offices or to create local "seats" of government. The ease of walking to meetings was replaced by parking as a criterion of efficient siting, and the feds began to leave downtown. The US Forest Service, US Army Corps of Engineers, Internal Revenue Service, and other key agencies relocated to office parks on the edge of the city. Downtown, which had already suffered from the rise of the malls and urban renewal, was being drained of one of its major assets.

In 1991 the federal General Services Administration launched a $38 billion federal courthouse building program. The city had to fight hard to persuade the federal justices to locate Albuquerque's new courthouse downtown—despite a GSA guideline that said first consideration for sites should be "a centralized business community and adjacent areas of similar character including other specific areas which may be recommended by local officials."

Local courthouses followed the federal courthouse downtown, and the federal Health and Human Services building was also built downtown. A vigorous return to the older policy of creating a federal district downtown would provide a significant market for transit, decrease the need for interoffice car trips, and allow the public to easily visit more than one agency. It would also reestablish a civic focus and rejuvenate downtown.

Bring back the feds.

SAVE THE SCHOOL'S SPIRIT
Anthony Anella

1998 Public buildings take on meaning in a community precisely because they are public and open to the shared experiences that help create a common bond of history. Because they are built with public money and are therefore subject to public scrutiny, public buildings articulate the collective values and aspirations of a people. They help define the character and cultural identity of a place. Other societies have churches to help them define their cultural identity. Our pluralistic, secular society has schools.

The old Albuquerque High School is such a complex of buildings. The original building, "Old Main," was built in 1914 just two years after New Mexico became a state. It served as Albuquerque's only high school until 1949 and continued to serve as one of several high schools in the city until 1974, when it was sold to a private developer. It remained in private hands until 1996, when the City of Albuquerque bought four of the five buildings for $1.5 million.

The Albuquerque Development Commission is currently [1998] evaluating two competing development proposals for the old high school. The commission has scheduled a final vote at a special meeting on September 9th, when it will choose one of the two proposals and recommend its choice to the city council. The council has the final say in choosing a developer.

At risk is more than the preservation of one of Albuquerque's most important historic landmarks. At risk is one of Albuquerque's and indeed one of any city's most precious resources: community spirit. After losing such landmarks as the Alvarado and Franciscan hotels, and after twenty-four years of the old Albuquerque High School being vacant, we, as a community, can't afford to miss this opportunity to develop the project in a way that benefits the greatest number of people and complements the development of the community as a whole.

The two proposals fundamentally differ in their treatment of the public character of the old Albuquerque High

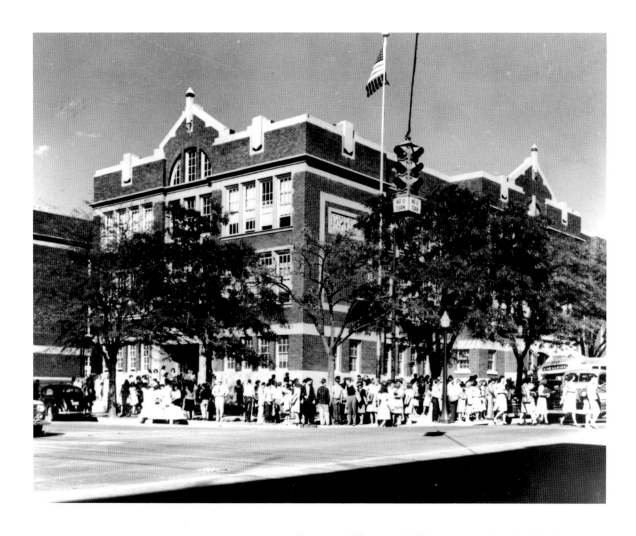

1947. This view of the original Albuquerque High School, looking east toward the northeast corner of Central Avenue and Broadway, shows the school teeming with life when it was the only high school in town. Courtesy of the Albuquerque Museum, Ward Hicks Collection, Gift of John Airy, 1982.180.36.

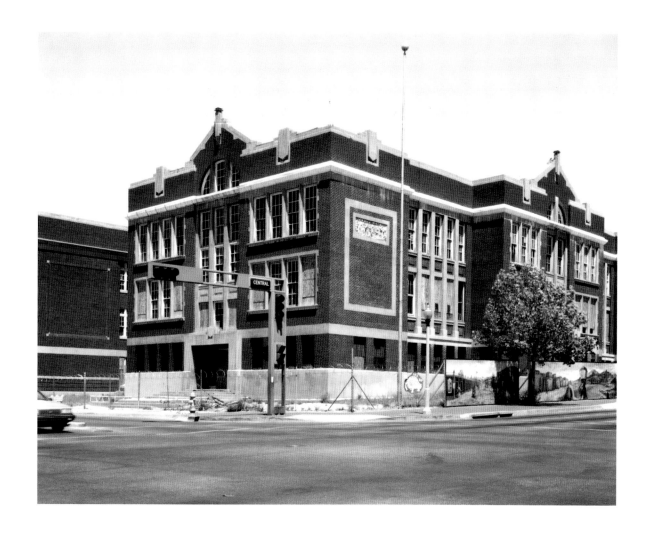

1998. This same view shows the old Albuquerque High School after twenty-four years of standing vacant and unused. In 2017 private apartments occupy the building. Photograph by Krista Elrick.

49

School and in their respective strategies for financing. The proposal by FarrMont Realty Group Inc. of Phoenix preserves Old Main as an arts and cultural center. The old gymnasium becomes a YMCA and daycare center. The old library becomes a new library to house the city's genealogy research collection. The old classroom building becomes either twenty-eight studio and one-bedroom apartments or office space. The manual arts building becomes offices and a restaurant. The FarrMont plan also includes either ninety-six more apartments with underground parking or an office building with underground parking on the vacant land to the north of the historic campus—depending on which alternative the city prefers.

The proposal by Paradigm and Co. of Austin, Texas, converts Old Main, the classroom building, and the manual arts building into 117 private apartments with limited access to the public. The gymnasium is converted into retail/office space, as is the library. The Paradigm plan also includes a four-story hotel and a parking garage to be built on the vacant land to the north of the historic campus.

The FarrMont proposal preserves the public spirit of the buildings by revitalizing their public use. It also creates a cultural node along the Route 66 corridor that connects the BioPark, Old Town, the University of New Mexico, and Nob Hill. The Paradigm proposal is based on the primary importance of providing housing as a strategy for revitalizing downtown Albuquerque. It assumes there is a preexisting market demand for downtown housing and ignores the fundamental question of which comes first: building more housing or creating amenities that will make downtown an attractive place to live. In contrast, one alternative of the FarrMont plan builds ninety-six apartments and helps insure their marketability by taking advantage of the adjacent gymnasium building by converting it into a YMCA and daycare center. The fatal design flaw of the Paradigm plan has to do with the simple act of carrying groceries from one's car to one's refrigerator. The seventy-nine apartments to be located in Old Main and the classroom building are separated from the practical necessity of parking by over two hundred feet, more than two-thirds of a football field. In contrast, the FarrMont plan builds ninety-six apartments conveniently located over an underground parking garage.

The FarrMont proposal costs the city less up-front money. It proposes to buy the four historic buildings owned by the city for $1.5 million and for the city to donate the lot to the north of the historic campus. FarrMont's total costs would be $28.5 million for the alternate with ninety-six apartments and includes $11 million of city subsidies with a total taxpayer cost of $1.8 million. In contrast, Paradigm's plan calls for the city to donate the buildings (including the manual arts building, which the city does not own) and to chip in $3.9 million—the difference between the cost of redevelopment and the estimated revenue. Paradigm's total costs would be $33 million for 117 apartments and includes $9.4 million of city subsidies with a total taxpayer cost of $9.35 million.

The challenge for each proposal is to generate enough cash flow to service the debt. FarrMont proposes a mixture of public uses (an arts and cultural center, a YMCA and daycare center, and a library) and private uses (housing, offices, and a restaurant) to generate cash flow. In contrast, Paradigm proposes private uses (housing, offices, a hotel, and a restaurant) exclusively to generate cash flow. But the fact remains that a financial pro forma that projects cash flow is not worth the paper it is written on unless it is based on a design that meets the needs of the market. The FarrMont plan does this by paying attention to the practical necessity of parking being conveniently located next to housing, and by taking advantage of the gymnasium for use as a marketable amenity to attract people to live in the development and help insure the project's success.

FarrMont manages its risk by requiring the city to provide its credit as backing for bonds to pay for the development and to make up any shortfall between the revenue generated by the completed project and the bond payments. In contrast, Paradigm manages its risk by asking the city to donate the historic campus and then by carving the historic campus into four separate properties controlled by four different developers. Tennessee developer Robin Miller would own Old Main and the classroom and manual arts buildings. Minneapolis-based developer Platinum Properties would own the property to the north of the campus. Albuquerque developer Rick Davis would own the library. Another as yet unknown developer would own the gymnasium.

From the community's point of view, the issue of risk can perhaps best be analyzed on the basis of what is more appropriate for the taxpayer to subsidize. The Paradigm proposal requires a $9.35 million taxpayer contribution for the opportunity to subsidize housing for the benefit of a few. If the project fails under the Paradigm plan, the old Albuquerque High School will be sold by four developers with disparate self-interests. In contrast, the FarrMont proposal requires a net taxpayer subsidy of $1.8 million and the city's credit in return for the revitalization of a public place to be enjoyed by all. If the project fails under the FarrMont plan, the city will be responsible for paying off up to $8 million in bonds. But the old Albuquerque High School will be left intact and the property will revert to the city—enhanced by development for the public good.

2017 As it turned out, of the two competing redevelopment proposals for the old Albuquerque High School discussed in the original article, the privatization of the school won out. Paradigm and Co. converted the school buildings into private housing. As a result, their historic nature is enjoyed by only a handful of residents. So, the buildings were saved, but the spirit of the school as a public institution was not. Nevertheless, the old Albuquerque High School was saved, representing an important victory for preserving an important place in our community that connects us to our history and contributes to Albuquerque's sense of itself as a place that matters.

STILL THE CHAMPION
Mark C. Childs

1998 Former senator Pete Domenici grew up across the street from the Champion Grocery Building. And, indeed, the building was placed on the New Mexico State Register of Cultural Properties in 1977 not only because it is a fine example of a neighborhood grocery but also because it was one of the centers of Albuquerque's Italian community.

In 1904 Alessandro Matteucci and his brother built a grocery store and family residence on the corner of Seventh and Tijeras. For thirty-eight years Alessandro ran the Champion Grocery, and for another nineteen years other grocery or meat markets operated at the building.

The corner grocery is emblematic of an earlier era. Its nostalgia value, however, is not what makes the Champion Grocery Building a champion urban building and model for our future.

The Champion has proved remarkably adaptable. At least two additions have been made to the original building without destroying its character. Despite being built before there were many cars, it has thrived throughout the automobile era.

The second floor was designed as the family residence, yet after twenty years it became a set of apartments. During the following seventy-four years, at least one hundred people have lived upstairs.

The rooms of the first floor have, in the years since the Champion Grocery closed, housed Hawkins Grocery, various meat markets, the Gypsy Beauty Salon, Leo's Upholstery Shop, Orr Refrigerator Service, Holland Furnace, Globe Tailors, the Korea Karate Institute, Sancar distributors of toys and games, the Uniform Store, and Gamelsky Benton Architects.

Yet throughout all these changes, the essential nature of the building has endured. It may be a bit the worse for

wear, but store windows still face the sidewalk, residences remain upstairs, the building is still part of its neighborhood, and the mosaic on the corner threshold continues to say "Champion."

The Champion does not offer undefined "free" space, nor was it designed to the other extreme, in which forms fit like a spacesuit to every detail of the original occupant. Rather, the building was designed to fit the city—commercial rooms adjacent to the sidewalk, residential rooms upstairs, service and, later, parking to the rear. This straightforward strategy has allowed the building to survive even as parts of it changed tenants or were vacant. Uses as diverse as a refrigerator-repair service and a karate institute have found space to fit their needs.

The building is also part of its neighborhood. It is not an isolated sculpture set behind a moat of parking but helps make a lively sidewalk, street, and neighborhood. Amid a residential neighborhood, it provides both homes and neighborhood services. Set next to the sidewalk, it encourages window-shopping and helps make the street a pleasant place to be, rather than merely a place to drive through.

Moreover, it accommodates the automobile but is not controlled by parking. Its mix of uses and integration with the neighborhood has, over the years, eliminated many driving trips. Not only did Alessandro live upstairs from his work for four or five years, but, more important, for nearly a century residents could walk downtown to work, neighbors could have lunch across the street, and business owners could walk to city hall.

The Champion could not easily be built today. Typical zoning regulations prohibit a mix of uses within a building or even within a neighborhood. The original intention of such uniform zoning was to protect residential neighborhoods from invasion by noxious factories and the like. Zoning evolved, however, to exceed this sensible function and eliminated many types of buildings and districts that make a city a delightful and economic place.

Furthermore, the details of present zoning have made it nearly impossible to build even single-use buildings that support a pleasant, walkable city. The requirement that commercial buildings be set back from the sidewalk and the excessive requirements for off-street parking spaces, to name just two of many problems, make it impossible to build a new Nob Hill, Old Town, or a Champion.

However, inappropriate regulations would not be the only obstacle to building the Champion today. Banking practices make it difficult to finance housing over stores. Businesses are owned by corporations based all over the planet, and the design of their buildings is dictated by generalized marketing formulas. And we have become so heavily invested in automobiles that few of us consider walking or bicycling to work or the store. It is not surprising that architects all too often build isolated structures or bland warehouses rather than adaptable and delightful parts of the city.

But the Champion is still with us, decade after decade, proving there is another way—a way that, if we change the rules again, could flourish in a new century.

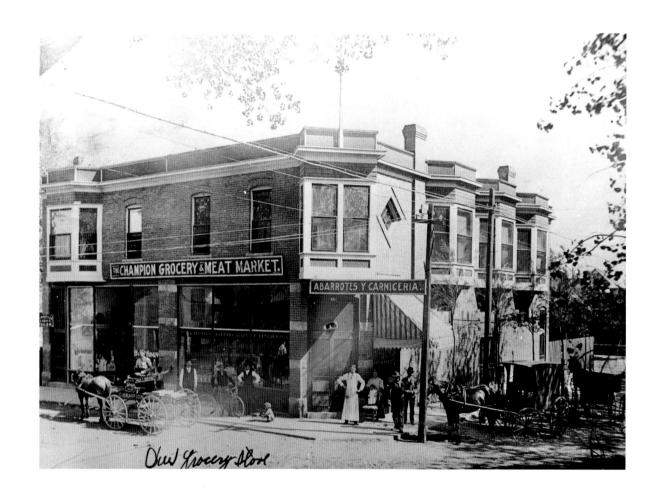

THE CHAMPION GROCERY & MEAT MARKET.

ABARROTES Y CARNICERIA.

Our Grocery Store

1910. The Champion Grocery was a lively part of the largely Italian neighborhood where it stood. Courtesy of the Albuquerque Museum, Gift of Yolanda Marianetti-Matteucci, 1975.063.496.

54

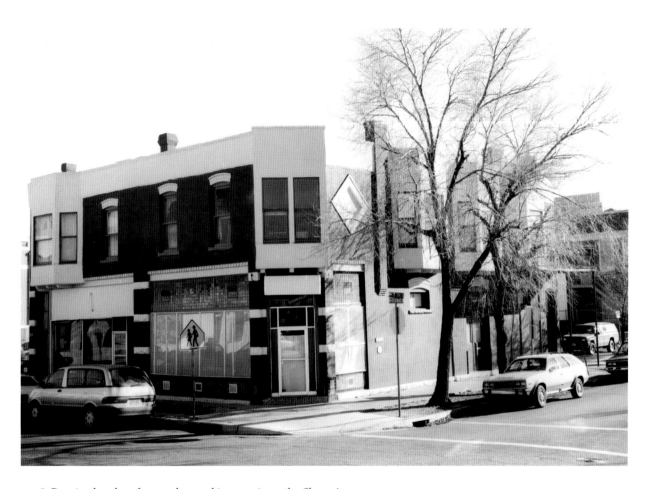

1998. Despite decades of use and several incarnations, the Champion Building retained its identity and usefulness and remains a good model for city buildings. However, later twentieth-century city regulations made it difficult to build structures such as the Champion. In 2017 the Champion Building has been restored and remodeled to house the Albuquerque Community Foundation, and thanks to national trends in zoning, city regulations now more easily allow mixed-used buildings such as the original Champion. Photograph by Krista Elrick.

2017 In 2012 the Albuquerque Community Foundation moved into the renovated six-thousand-square-foot Champion Building. The heirs of the Champion's original owner, Paul and Patti Marianetti, donated it to the foundation because, as a December 2011 interview in the *Albuquerque Journal* notes, they wanted the building to continue its storied life as an anchor for the community.

The remodel brought much of the Champion's original character back to its facades and provided office space for the foundation and a large meeting room used by numerous groups. The project received a NAIOP (Commercial Real Estate Development Association) award and an Associated General Contractor's award in 2012. If Albuquerque had an award for contributing to the urban fabric or reinvigorating a community hub, then this project would certainly have won that also.

Randy Royster, president and CEO of the Albuquerque Community Foundation, says the move to the Champion reflects the foundation's mission in multiple ways. The foundation is fundamentally dedicated to the long-term vitality of Albuquerque and having a permanent home rather than a rental space makes concrete that mission. The adaptive reuse of the Champion also demonstrates a respect for the city's roots, and because they set a hundred-year design standard for the remodel, it also shows a commitment to the city's future. Moreover, the Champion provides a community gathering space used by other nonprofits, community groups, and the City of Albuquerque. The foundation's presence downtown reintroduced downtown to older donors and eases collaborations with other downtown agencies. Most fundamentally, as Randy Royster (pers. comm.) says, "The foundation is in the business of telling Albuquerque stories. The Champion is one of those great stories."

REVIVING DOWNTOWN
Anthony Anella

1998 In 1942, at about the time when the historic photograph of the Washington Apartments was taken, Albuquerque was a much different place. The population was a little over thirty-five thousand. In the area bounded by Lomas, Broadway, Coal, and Eighth Street, there were approximately 730 individual dwelling units, fourteen apartment buildings, and thirty-one flats. There were also twenty-two hotels including the Hilton (now Hotel Andaluz), Alvarado, Franciscan, El Fidel, and Coombs. And there were three schools. By 1990 the same area (Census Tract 21) had 420 housing units of which 92 were vacant, and the Alvarado, Franciscan, El Fidel, and Coombs, as well as most of the other hotels, had all been torn down. What we lost in the disintegration of downtown as the vibrant center of our city is a shared connection to the public realm and civic life of our town. We lost a sense of community.

Contemporary American cities are built for a variety of reasons. Only rarely do these reasons have much to do with the comfort and physical ease of the people who live in them. There is an ironic disconnect between what is convenient for the residents of our cities and what is expedient for the developers of our cities.

For example, in Albuquerque houses are built on the suburban fringe because the land is cheaper and more easily developed. By developing the relatively large tracts of land at the edge of the city, developers are able to take advantage of economies of scale that are lost when just a few infill houses are being built. These economies of scale derive not only from the process of construction contracting but also from a complicated government approval process. Whether the project is for development of a large tract of land or a small infill parcel, the approval process is basically the same. Consequently, developers go where they get a greater return on the time spent obtaining the necessary approvals. In effect, by failing to differentiate between suburban and infill development, the city's

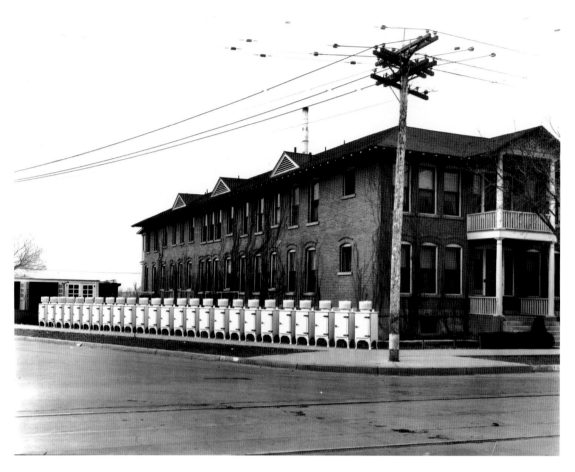

1940. A row of Albuquerque Gas and Electric refrigerators lines the sidewalk in front of the Washington Apartments in this view of the southwest corner of Central Avenue and Tenth Street. No information is available as to why the refrigerators were standing there. The apartment building was one of fourteen at the time that housed residents in a thriving downtown. Courtesy of the Albuquerque Museum, Brooks Studio Collection, Gift of Channell Graham and Harold Brooks, 1978.151.019.

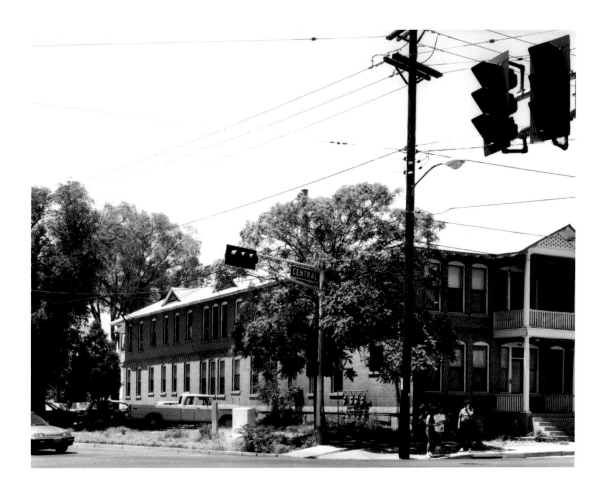

1998. This same view of the Washington Apartments shows the apartments still in use. However, far fewer housing units were available in downtown in 1998 than in 1940. In 2017 there are more apartments in downtown than in 1998. Most of the apartments are for low-income housing. Still, as a direct result of this increase in housing, downtown now has a grocery store. Photograph by Krista Elrick.

approval process promotes suburban growth. It is also easier to get projects approved on the outskirts of town where there is less public opposition from neighborhood associations. In addition, it is easier to get projects funded by lenders who prefer "tried and true" suburban development. Real estate developers and their lenders know that certainty of approval will reduce costs and processing time, thereby allowing new developments to be brought to market more quickly, more cheaply, and more successfully.

The revitalization of downtown Albuquerque depends on the development of downtown housing. For this to happen developers must be persuaded that they can overcome the market forces, government policies, and habits of financing that have become entrenched impediments over time. Further, they must be convinced that they can answer the following question for the buyer: How am I getting more for my money by living downtown?

This question is difficult to answer given the relatively high land prices in downtown Albuquerque compared to the relatively cheap land on the suburban fringe. This disparity contributes to the perception that the suburbs are less expensive than urban alternatives. However, this perception does not reflect the increased commuting costs to the individual homeowner nor the increased infrastructure costs to society of new roads and utilities.

In a speech at the Brookings Institute, Vice President Al Gore (1998) outlined a new federal program that recognizes "an economic reality that has long been ignored by our mortgage system: families that live near mass transit save as much as hundreds of dollars a month, and therefore should qualify for larger mortgages." The program takes into account the transportation inefficiencies of suburban fringe development by providing a mortgage break for homeowners who buy where they don't have to commute as much. Such a mortgage break could help offset the relatively high cost of downtown land and make the development of downtown housing financially more feasible.

Chicago has been selected for a $100 million pilot program to demonstrate the concept. Other cities being considered include Seattle and Los Angeles. Why don't Mayor Jim Baca and the New Mexico congressional delegation lobby to have Albuquerque considered for a similar pilot program?

If Mayor Baca is seriously interested in promoting infill development in places like downtown, then he must facilitate the process by dedicating city staff to work with the neighborhoods to identify their concerns and define the parameters of possible projects prior to the private developer becoming involved. Further, he could make a significant contribution by streamlining the process of approving infill development if certain design objectives are met. More certainty is needed in delineating where new development should and should not occur so that developers and their lenders can be reassured that new developments can be brought to market more quickly and less expensively.

As a community we need to be more explicit about our priorities for development by targeting actions and

policies that will better integrate our preferences for development with the expediencies of development. Residents of the older urban and suburban neighborhoods as well as residents of the newer suburbs share a common interest in revitalizing the downtown core, shortening commute times, reducing automobile pollution, preserving what remains of our natural and cultural heritage, and promoting a renewed connection to the civic life of our town.

2017 The disconnect between what is expedient for the developers of our cities and what is convenient for the residents of our cities has to do with how our economic system is focused on the short term at the expense of the long term. The conventional way we conduct business— how our accounting systems conveniently externalize the environmental costs of human enterprise, thereby distorting our understanding of our true ecologic and economic well-being—is an example of this.

That we allow our accounting systems to externalize long-term costs is the result of an overarching disconnect: the idea that somehow we are separate from nature rather than part of nature. As economist David C. Korten (2010, 245) writes, "The greatest barrier to the economic transformation we seek is not corrupt politicians [or] greedy CEOs. . . . It is a flawed cultural story that misinforms our collective understanding of our nature and possibilities as humans and of the world we inhabit." Nature doesn't work in the short increments of time that preoccupy our business leaders. To reconcile this disconnect we need a new cultural story.

Extricating ourselves from our current ecologic and economic predicament is analogous to the challenge of landing a man on the moon. It will require long-term planning. This is the proper role for government. The fact is, businesses have to plan in relatively short increments of time in order to keep their doors open. Only a city, a state, or a nation can marshal the vision and funding necessary to launch long-term missions without immediately calculable financial returns. Landing a man on the moon was not possible without NASA. Every great exploration in history including Magellan's trip around the globe, the Lewis and Clark Expedition, and the search to find a cure for cancer has been sponsored by government. The search to find a sustainable way of living on our planet is no different.

How to design and build our houses and cities in energy-efficient ways is an example of the long-term planning that can best be accomplished by government. For fifty years, housebuilders operated on the assumption that abundant supplies of inexpensive energy made it easier to pump vast amounts of cold air into houses in the summer and hot air into houses in the winter than to build energy-efficient homes. And it is easier for them. Once a house is sold, the housebuilders do not have to live with the long-term costs of heating and cooling it. For the sake of a more competitive initial purchase price, housebuilders prefer not to have to account for wasteful energy use over the life of the house.

Housebuilders get away with this because the contemporary American house buyer favors the short-term advantage of a lower down payment on a smaller mortgage over the long-term advantage of energy efficiency resulting from responsible design and construction. Rather than pay for overhangs to shade windows from the sun, higher insulation values, or heat-reflecting roofs, the contemporary American house buyer favors larger houses with more space to heat and cool. The prevailing attitude is to postpone until the future what you don't have to pay for today.

According to the National Association of Home Builders and the US Census, the average new house floor area increased from 983 square feet in 1950 to 2,266 square feet in 2000. During this same period the number of family members per household decreased. This resulted in an increase in the floor area per capita from 286 square feet in 1950 to 847 square feet per capita in 2000. As modern Americans we have grown fat from our indulgent preference for bigger and bigger houses—at the expense of creating a legacy of well-designed and well-built, energy-efficient homes for our children.

For fifty years the marketplace ignored the long-term costs of building poorly designed and poorly constructed homes. It ignored the long-term costs of energy consumption that can burden a family's annual budget. And it ignored the consequences to a family that finally pays off the thirty-year mortgage only to find that their equity has evaporated due to poor design and construction and the depreciation of their house's value because of higher costs to heat and cool it. On the consumption side of the marketplace, this false economy has to do with living in an age of instant gratification where success is defined by the realization of short-term goals. On the production side, it has to do with the fact that the interests of large, publicly traded housebuilding corporations with responsibility to their shareholders may not coincide with the long-term interests of our community.

Another example of how government can help sponsor the long-term planning necessary to ensure that Albuquerque is a sustainable place for our future is the development of our city as a whole. Most new houses in Albuquerque are built on the suburban fringe. This is because the land is cheaper and more easily developed. It is not because it is more economical for the taxpayers of Albuquerque who are burdened by having to pay the cost to extend water and sewer services as well as roads to the outskirts of town. Nor is it because it is more economical for the home buyer who is burdened by the long-term costs of commuting. As with the construction of energy-inefficient houses, developing land on the edge of our city is based on a false economy, one that conveniently externalizes the environmental costs of the automobile pollution that results from long commutes. This undermines our true ecologic and economic well-being, not just for ourselves but for our children.

Two facts lead to a critical question. First, housebuilders are not rewarded financially by the appreciation of long-term value; they are only rewarded by the profit margin at the time of the initial sale. Second, the enhanced value

of well-designed and well-built, energy-efficient homes contributes positively both to the individual property owner's equity and to the local government that depends on appraised value as the basis for property tax revenue. The critical question is, how can the short-term profit that motivates the house builder be harnessed to the creation of long-term property value?

The answer to this question involves two different roles for government. Both have to do with constructing our houses and developing our city in ways that we—as citizens—choose in order to promote the long-term interests of our children and community. The first role is regulatory and prescriptive ("thou shalt install better insulation in the walls and ceilings of new homes"). Albuquerque used to have an Energy Conservation Code requiring the development and construction of energy-efficient buildings providing long-term competitive advantages in the costs to live and work in our city. Unfortunately, in 2011 the Albuquerque City Council voted 5–4 along party lines to repeal the code. The repeal effort was led by a coalition of housebuilders and the administrations of Albuquerque mayor Richard Berry and New Mexico governor Susana Martinez. By failing to consider the long-term return on investment for our community by building well-designed and well-constructed homes, Mayor Berry and Governor Martinez subordinated our children's future prosperity to the short-term interests of housebuilders and to their own personal political ambitions.

The second and perhaps more effective role for government is to establish policies that seek to reconcile the disconnect between how our economy works financially and how nature functions ecologically. For example, if a house is designed with overhangs to shade windows from the sun, has higher insulation values, and heat-reflecting roofs, the buyer of that house will pay less of his annual budget to heat and cool it. It makes sense for the financing of the house purchase to reflect this. Less money spent on heating and cooling equals more money to pay a mortgage. Similarly, less money spent on commuting from distant suburbs equals more money to pay a mortgage. Unfortunately, how banks finance our homes does not reflect the long-term advantages of building energy-efficient homes and transportation-efficient cities. This is because the banks are focused on making short-term profits. To resolve this discrepancy, the government can promote programs that take into account the long-term costs to society of building poorly designed, energy-inefficient houses by providing a mortgage break for homeowners who buy energy efficient homes. The government can promote programs that take into account the long-term inefficiencies of suburban fringe development by providing a mortgage break for homeowners who buy where they don't have to commute as far. Such mortgage breaks would help offset the cost of building more energy-efficient houses and more transportation-efficient cities. Such mortgage breaks would more closely align the way our economic system finances development with the ecological realities of our planet.

Providing financial incentives to build more energy-efficient houses and develop more transportation-efficient cities helps internalize the ecological costs of development and helps reconcile the disconnect between ecology and economics. In effect, recognizing and rewarding development practices that benefit the ecologic system as a whole discourages the development practices that do not.

The revitalization of downtown depends on the development of housing there. For this to happen developers must be persuaded that they can overcome the short-sighted market forces and bad habits of financing that conspire to promote the poor-quality development on the outskirts of Albuquerque. Recognizing and rewarding the more ecologically sensible development of infill properties in and around downtown with mortgage breaks would help offset the relatively high cost of downtown land and make development of downtown housing financially more feasible for the house buyer and ecologically more sustainable for Albuquerque.

What if realizing the American Dream was redefined so it did not mean living in ever bigger houses and driving ever more luxurious cars, but rather it meant living within our economic and ecologic means? It will not be easy. The same culture of borrow and spend that afflicts our economic health also afflicts our planet's ecological health. The solution is a matter of taking individual responsibility for reestablishing a culture of save and invest. It is something we owe to our children.

A SALUTE TO SOUVENIRS
Mark C. Childs

1998 Two days before the bulldozers came to flatten the Covered Wagon Souvenir Shop to make way for the freeway, Manny Goodman concluded his going-out-of-business sale and moved his venture from the edge of town to its ancient center—Old Town Plaza.

Goodman built his original shop with its faux covered wagon, concrete tepees, and six-foot-tall jackrabbit just outside the eastern edge of the city limits in the late 1940s. His two donkeys were the delight of children traveling Route 66 and the favorites of locals who came to the shop on outings from the city.

Built at the bottom of Tijeras Canyon where the view from Route 66 opened onto the valley, the Covered Wagon for more than a decade created a kind of portal and edge to Albuquerque. It was a prime example of the typically postwar American mix of rest stop, mythic interpretation center, and amusement park. *Life*, *Look*, and *Holiday* magazines all ran spreads on the Covered Wagon.

History is a critical component of New Mexico's economy and culture. History employs —to name a few— anthropologists, artists, storytellers, architects, and souvenir salesmen. Those of us promoting historic conservation, architectural regionalism, or guardianship of history and place must acknowledge our connection to souvenir salesmen, our fellow purveyors of memory and the myths of place. I would like to point out three connections between souvenirs and architecture.

First, the history of Albuquerque's souvenir trade itself sheds light on the city's architectural development. The Alvarado Hotel at Albuquerque's railroad station was, for much of its life, the center of town and tourism. The original Covered Wagon, however, got its life and character from the railroad's upstart rival, Route 66.

By 1957, when Goodman was forced to relocate for the dawn of the freeway era, homeowners and businesses across the country were fleeing from downtowns, and the

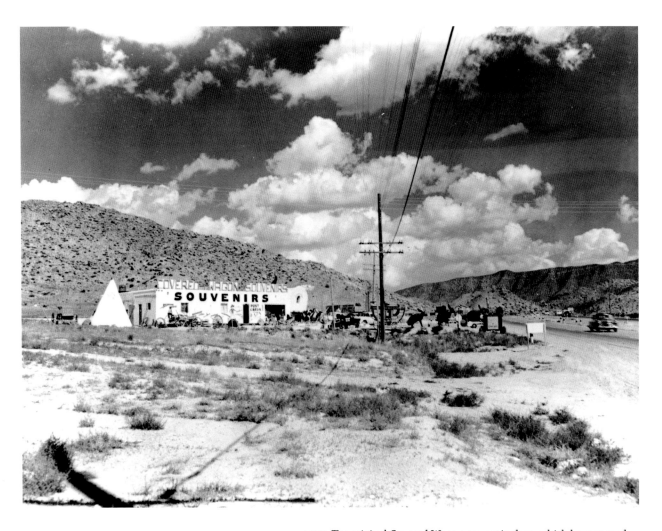

1955. The original Covered Wagon souvenir shop, which later moved to Old Town, stood on Route 66 at the bottom of Tijeras Canyon, near where Four Hills Road is now. With its giant rabbits and concrete tepees, it was a gateway for tourists arriving in the valley. Courtesy of the Albuquerque Museum, Gift of Manny Goodman, 197.008.051.

1998. In this shot at the same location in 1998, the Tramway-
Interstate 40 interchange dominates the site. Photograph by Krista
Elrick.

suburbs were rapidly expanding. Winrock Mall, for example, opened in the early 1960s, following a national trend of malls blooming at the edge of cities. Manny Goodman, however, chose to move to the plaza. His colleagues in the trade predicted that he wouldn't last six months. His shop remains active to this day.

Goodman and the other souvenir merchants of Old Town saw that they could trade the Route 66 environment of fake wagons and tepees for an environment with a more rooted mythic depth. During that same year, 1957, the historic zone for Old Town was adopted.

Second, the giant cowboy hats and pretend icebergs of Route 66 shops can be studied as the roots of the architectural movement called postmodernism, in which historic and cultural images are played with—buildings are decorated with giant newly hatched Greek goddesses or statues of the Seven Dwarfs. The seminal architecture book, *Learning from Las Vegas*, by Robert Venturi, Denise Scott Brown, and Steven Izenour, is in fact a call for architects to examine Route 66 development and design.

Finally, souvenirs themselves speak about place and time in ways that illuminate how buildings can be vehicles of memory.

There are two types of souvenirs—relics and reflections. Relics are old objects created for various purposes that become keepsakes because they evoke the time and place of their origin. Some relics tell quiet stories and speak of the origins *and* subsequent eras. Reflections, on the other hand, are created to tell a story about a place and time.

The railroad repair shops in Barelas are relics. The Covered Wagon was a reflection.

Reflections tend to be considered of lower pedigree than relics. Relics, after all, contain clues to questions we haven't yet asked, whereas reproductions reflect a present image of the past. A modern Santa Fe–style house rarely tells us anything new about earlier times.

Pedigree, however, can become a complex and stifling issue. Does the 1920 addition to an 1890 house improve or blemish its historic value? Should a new building never reflect history, lest it be considered a cheap souvenir? What is the value of an old artwork that is a riff on an even older piece—such as the US Capitol that reflects Greco-Roman styles?

Perhaps we need a more versatile means than pedigree to weigh the value of souvenirs and historic buildings. Rather than judging a building on its historic veracity, I suggest we ask the more difficult but emotionally richer question—does it tell a compelling and enlightening story?

A $1.99 factory-made dreamcatcher can weave a story to calm a six-year-old's nightmares. The KiMo Theatre continues to delight audiences and enliven downtown. Whether they are tall tales or true epics, beloved souvenirs evoke the past and a sense of a place to make us think, feel awe or comfort, cry, laugh, or smile.

Manny Goodman retired in 1998. I would like to salute this masterful storyteller. The Covered Wagon was a wry and whimsical tale.

THE UNIVERSITY OF NEW MEXICO AND ALBUQUERQUE
Anthony Anella

1998 More than any other institution in our community, the University of New Mexico (UNM) contributes to our quality of life. Imagine Albuquerque without it. No UNM Hospital or Cancer Research Center. No Popejoy Concert Hall. No Lobos. No education or research programs to help drive statewide economic development. No Maxwell Museum of Anthropology or University Art Museum. In short, no institutionalized pursuit of higher education and knowledge.

In spite of these profound contributions, UNM, like any state university, suffers from a fuzzy public image. It doesn't seem to have a clear idea of its relationship with the larger community. On the one hand, as a publicly funded institution, it faces the imperative of serving its constituency, of reflecting the needs of society as translated by politicians. On the other hand, as a campus of intellectuals devoted to open debate, free inquiry, and scholarship, it has an obligation to serve the world of ideas, to protect a place that exemplifies the highest ideals of society. On the one hand, the university is shaped by politics; on the other, it helps to shape politics by elevating the public discourse as well as by raising society's expectations for excellence.

This confusion on the part of the university expresses itself in two buildings that, by virtue of what they house, offer two contrasting examples of how the university chooses to relate to Albuquerque and the larger community. One building, the new bookstore, is located at the southern edge of campus between Central Avenue and the campus loop of Redondo Drive. The other building, the University Museums Downtown, is located at 516 Central SW in the heart of the business district. Each building, and in particular what each building contains, projects two very different images of the university to the community.

The large windows along the bookstore's southern elevation expose an interior filled with T-shirts and souvenirs. There is no evidence of books as you drive by the building

1981. This view looking south shows May's Music Store on Central Avenue downtown. Courtesy of the Albuquerque Museum.

1998. This same view shows how the music store was transformed into the University Museums Downtown. In 2017 an independent, nonprofit art space called 516 Arts occupies the building. Photograph by Krista Elrick.

71

on Central Avenue. Two-foot-high letters in the windows are necessary to proclaim the fact it is a bookstore. They are the only hint of what the building is about. Even when you enter the building, the overwhelming first impression is one of commerce, not education. The entry is filled with ATMs, ticket windows, and a convenience store offering soft drinks and junk food. Once inside the main space, the textbooks are still nowhere to be seen. They are hidden by a grand staircase and elevator tower at the west end of a long, pseudoreligious nave. Halfway down this nave is a Starbucks.

The bookstore is about marketing and merchandising, not higher learning. Locating the bookstore at the edge of campus makes sense as a way of facilitating sales to the public that subsidize the cost of student textbooks. But why does the UNM Bookstore choose to market itself by exalting the sweatshirt when places like Barnes and Noble and Page 1 Books make profits by exalting the book? Such a misguided strategy reflects a commercial orientation to Albuquerque on the part of the university premised on a cynical assumption that the consuming public would only visit the UNM Bookstore to buy a souvenir. As a significant interface between the university and Albuquerque, the bookstore not only degrades higher education, it also demeans the intelligence of the public. It projects a public image of the university as a convenience store rather than as an institution of higher learning.

The University Museums Downtown projects a very different image of UNM. It contains branches of both the University Art Museum and the Maxwell Museum of Anthropology. By simply offering downtown office workers the opportunity to spend part of their lunch hour looking at art, the University Museums Downtown is an outpost of the high values of the university. It also makes a significant contribution to the types of amenities that are essential for the revitalization of downtown Albuquerque both as a desirable place to work and as a desirable place to live. Finally, the University Museums Downtown is good for the university because it demonstrates, in a tangible way, part of what the university gives back to the community that supports it.

Ironically, just when there appears to be momentum building for the revitalization of downtown, the university is considering whether or not to close the downtown museum. This is because it costs more to operate than it generates revenue. Nevertheless, closing it would send the community the wrong signal at the wrong time. Rather than close the downtown museum, a better solution is to make it financially self-supporting. This may mean selling books at the front of the museum as a branch of the UNM Bookstore. Currently, there is no bookstore downtown. Revenues from book sales could help offset the cost of staffing the museum. To increase attendance, the university might consider a brown-bag lecture series presented by distinguished faculty members from various departments. Businesspeople downtown might enjoy the intellectual stimulation, and faculty might enjoy the opportunity to lecture outside of academia. It is worth a try.

One way the university can sharpen the focus of its fuzzy public image is by remaining true to the idealism of higher education as a profound force elevating the culture of New Mexico. It is possible to be fiscally prudent without marketing to the lowest common denominator. Keeping the downtown museum open would serve as an intelligent example.

2017 The way UNM thinks about Albuquerque and the way Albuquerque thinks about UNM both need to change. For too long, suspicions on both sides have prevented constructive collaboration. To prosper and to thrive, both the university and the city need to realize that such collaboration is mutually beneficial: the success of one promotes that of the other. A successful university promotes Albuquerque's economic, social, and cultural vitality. A successful city makes UNM more attractive to the faculty and students most capable of making the university more successful. UNM and Albuquerque are in the same municipal boat. They should row in the same direction.

Writing in the *Chronicle of Higher Education*, Richard M. Freeland (2005, 2) identified three kinds of interactions that historically have characterized the "town-gown" relationship. First are what he calls "incidental impacts": universities provide jobs, spend money, construct buildings, attract research dollars—all by-products of the university's effort to strengthen its academic mission. Second are the "intentional contributions" that occur when a university sets out to strengthen its community: service learning and internship programs that place students in community-based organizations; research institutes that focus on regional development; hospitals that provide health care; art museums, theaters, and concert halls that provide venues for artistic expression. Third is the "extracted benefit," something the city demands of the university as a quid pro quo: the university needs a zoning change; the city wants a park; the latter is the price of the former. Freeland advocates for a new model of town-gown relations. Citing the report "Leveraging Colleges and Universities for Urban Economic Revitalization," he writes that "leveraging academic assets . . . remains one of the greatest untapped urban revitalization opportunities in the country" (Freeland 2005, 2).

Albuquerque has a competitive advantage in terms of academic assets. What other city in America has a premier national laboratory and a flagship state university in the financial hub of an entire state? The Bay Region and San Francisco, perhaps, but Albuquerque's resident brainpower may be our city's ace in the hole.

"Innovate ABQ," a remarkable collaboration between the University of New Mexico and the City of Albuquerque, promises to tap into our academic assets to revitalize our community. It is one of the most exciting new initiatives to come along in years. It has the potential to leverage our city's resident brainpower—both at the university and at Sandia National Laboratories—in the service of making Albuquerque a more vibrant and vital place to live and work.

The purchase of Innovate ABQ's future home, the former First Baptist Church property at Central Avenue and Broadway, was made possible by a $3 million contribution from the New Mexico Educators Federal Credit Union (now Nusenda). This is noteworthy because it points the way toward a new business model for banking in our community. Since 1992 Albuquerque has been hamstrung by our banks being owned by out-of-state interests with little or no self-interest in helping to make our community a more desirable place to live and work (see "Banking's Interest in Albuquerque's Future," page 13). Something like Innovate ABQ, which has the potential to help Albuquerque over the long term, simply does not factor into their business strategy. Nusenda is the only financial institution to support Innovate ABQ in a significant way. Nusenda is also one of the very few locally owned financial institutions in Albuquerque.

Another factor that has hamstrung Albuquerque's economy is our dependence on federal money. For too long Albuquerque's future has been harnessed to the federal yoke by politicians with too little imagination to think of anything better and just enough seniority to bring home the pork. This is a shortsighted strategy with little promise of making Albuquerque the kind of place our children and children's children would want to live and work in. Albuquerque needs to wean itself from our dependence on federal money and shift our focus onto real economic development—the kind that has to do with creativity and innovation. Albuquerque needs to improve its trade imbalance by exporting more products to the rest of the country and the world. By collaborating in creative ways like Innovate ABQ, the University of New Mexico and the city have the potential to help. An example of this potential is unfortunately illustrated by a missed opportunity. Recently, a UNM researcher discovered that lemongrass oil kills the mosquitoes responsible for the Zika virus. Why didn't the city step in to develop funding sources for marketing this discovery? Let us hope that Innovate ABQ fulfills its promise of creating a town-gown culture that attracts the innovators and entrepreneurs we need to make Albuquerque a truly vibrant and vital place to live and work.

Another competitive advantage Albuquerque has is in the arts. Santa Fe may be the city in New Mexico where the arts are primarily *consumed* by out-of-state visitors, but Albuquerque is where the arts are primarily *produced*. In large part, this is thanks to the university. Whether it is in the visual arts or in the performing arts, the university creates an intellectually stimulating environment that nurtures creativity and innovation. This is important beyond the mere consumption of art. The arts and the sciences spring from the same source: an open mindset that by virtue of its openness is capable of seeing the world in new and infinitely creative and liberating ways.

The late Peter Walch, who served for fifteen years as a dynamic director of the University Art Museum, was responsible for opening the University Museums Downtown. That admirable example of UNM's "intentional

contribution" to Albuquerque unfortunately closed a few years after opening. But out of its ashes is rising a new, more comprehensive effort on the part of UNM to make a contribution to Albuquerque as a desirable place to live and work. Thanks to the entrepreneurial energy of Kymberly Pinder, the dean of the College of Fine Arts, the effort includes two initiatives. One is the already open College of Fine Arts Downtown Studio—what Dean Pinder (pers. comm.) refers to as a "micro-model of town-gown collaboration": the city provides the space and the university provides the content. The other is the Digital Arts Lab that the College of Fine Arts plans to open at Innovate ABQ. The goal of both, according to Dean Pinder, is "to help UNM faculty and students become better translators of the importance of art to New Mexico's economy." Both initiatives also provide interested UNM students the opportunity to demonstrate ownership in the larger community by connecting more directly with local organizations. They employ art as a critical voice aimed at generating dialogue and stimulating awareness, precisely the type of creativity that is essential if Albuquerque is to attract the innovators who can drive true economic development in our city.

Innovation results wherever clever people congregate, and clever people congregate where the quality of life and the opportunities for personal growth are greatest. In addition to the academic assets of its resident brainpower and the creative assets of its vibrant arts community, Albuquerque is blessed by a stunningly beautiful natural setting. Perhaps this natural beauty explains why Albuquerque attracted such cultural diversity and why Albuquerque has such a rich history. At a time when much of the country is becoming increasingly homogenized due to the predominance of a franchise culture (Taco Bells that look the same no matter where they are located), Albuquerque still has tangible evidence of authentic culture. This is another one of Albuquerque's greatest assets. By celebrating what distinguishes our city from Anywhere, USA, we enhance Albuquerque's attractiveness as a desirable place to live and work.

Ultimately, attracting the entrepreneurs capable of building and sustaining a truly creative economy depends on Albuquerque playing to its strengths. The university and the city can help by coming together to promote the academic, artistic, historically rich, and culturally diverse assets that make Albuquerque unique. The airport provides an example of the potential for such collaboration. Arriving at Albuquerque's airport, there is no mistaking it with that of another city. You know you have arrived someplace special. The airport's architecture and art collection celebrate our unique history and sense of place. Although both the building and the airport art collection belong to the city, the airport still provides a model for how the city, as the provider of essential infrastructure, and the university, as the protector of society's highest ideals and the generator of contemporary cultural content, can work together.

ELEMENTS OF STYLE
Mark C. Childs

1998 In 1898 Herman Blueher built a two-story, brick house over the ruins of an adobe house on the east side of Old Town Plaza. Behind his farmhouse stretched his market gardens on what is now Tigeux Park and the Albuquerque Museum campus. The building, with its hipped roof and heavy lintels, was Italianate in style—a style that had come to town with the railroad.

At least within modern architectural theory, style is one letter from being a four-letter word. The rhetoric of the early twentieth-century modern movement in architecture insisted that "style" was distracting and wasteful—it was "eyewash" that covered the functional and structural utility of architecture.

On the other hand, within the development community, architecture has often been relegated to "creating a style" after all the important decisions such as siting,

structural design, building layout, and parking location have been decided.

Style has become associated with activities such as picking "the look" for a house from options in a plan book, or conforming to a bureaucratic set of rules aimed at creating the image of some imagined past. Style has become the look without the life.

Yet style once meant a characteristic means of expression that reflects who we are as individuals and as societies. To paraphrase William Strunk's classic *The Elements of Style* (1979), style reveals something of the author's spirit, habits, capacities, and biases and is an inevitable product of the author's mind.

The real question of style is *what* habits, aspirations, and biases should be consciously expressed?

The style of a building may assert individuality and/or

solidarity with a group. When the Spanish came to New Mexico, they purposefully imported a style of building. After the railroad came to Albuquerque, the style of new buildings in New Albuquerque was midwestern railroad-Victorian, which included a number of sub-styles such as Italianate. This was part of an explicit effort to build a "modern" city and thereby to prosper. The style was also clearly allied with an Anglo-American culture.

From 1940 to 1954 La Hacienda Restaurant occupied the Pueblo-style Armijo house next door to the Blueher house. In 1954 the owners of the restaurant bought the Blueher house, added a Peublo-style front building, restyled the outside of the house itself by removing the pitched roofs and stuccoing over the brick—as is shown in the 1998 photo—and moved their restaurant to this structure.

Old Town was annexed by Albuquerque in 1949. Shortly thereafter, the Old Town Historic District was created during a rising tide of public interest in the history of architecture. The ascent of the historic-preservation movement and cultural tourism was a significant part of the time in which the Blueher house was converted into La Hacienda Restaurant.

Is the addition and remodeling not an economically successful expression of the social forces of its time? Doesn't it add a coherent enclosure of the plaza, continue the restaurant's association with the style of its former adobe, the Armijo house, and give its clients a sense of the long history of the plaza? The design of the renovated Blueher house complex was a conscious decision to identify with a social history and thereby to prosper.

But, say the purists, the Spanish-era houses and downtown Victorians were built according to their time. The restaurant, on the other hand, covered up a recent past in order to evoke a memory of a more-distant past. This, my imaginary purists would say, is a kind of lie. What's more, by glorifying the past, we are distracted from the difficulty of gracefully expressing our own time.

What is the appropriate style for the Blueher addition? Maybe neither the Victorian nor the modern Pueblo style is appropriate to this complex. The Victorian style was imported from another place, and the Pueblo style from another time. On the other hand, Old Town *was* once a Spanish pueblo, New Albuquerque *was* a railroad-Victorian town, and the current incarnation of Old Town *is* part of the world of cultural tourism.

Perhaps for our time the key to the puzzle of appropriate style is not in picking one heritage over another. Two Albuquerque developments suggest an alternative.

Architect Antoine Predock's La Luz compact townhouse development west of the river in a subtle way, and the KiMo Theatre in a bold manner, clearly are informed by the past but also responded to their times. These structures suggest that in a place rich with different historical styles, designers must rise to the challenge of finding a carefully finessed expression of multiple pasts, a complex present, and an unknown future.

1950. The Herman Blueher House, as it stood on the east side of the Old Town Plaza, was originally built in the Italianate style. Courtesy of the Albuquerque Museum, Photograph by Bob Harper, Gift of Kay Harper, 1996.009.002.

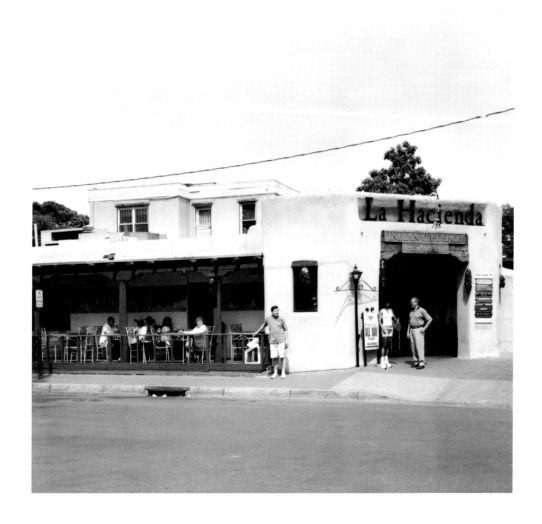

1998. The Blueher House was redone to sport a Pueblo style of architecture. It is currently the site of La Hacienda Restaurant. Photograph by Krista Elrick.

Perhaps by taking this nuanced approach La Hacienda Restaurant could have launched an "Italianate Pueblo" style. Clearly, the restaurant, built in the yard of an Italianate farmhouse, across the street from an ancient church, during a floodtide of tourism, was from this perspective a difficult design problem—a type of problem, however, that we face every time we build with care for the city and its history.

"There is no satisfactory explanation of style, no infallible guide," Strunk (1979, 66) warns. It is not a matter of putting on one costume or another but of finding the best expression of who we were and who we can be.

THE "PUEBLO ON THE MESA"
Anthony Anella

1998 Completed in 1892, Hodgin Hall was the first building to be built on the University of New Mexico campus. The three-story, gabled, red-brick structure sat in the middle of a sandy tableland studded with yucca and native grasses that stretched to the Sandia Mountains. The tableland was like a vast tabula rasa on which Albuquerque was to inscribe its vision of what it wanted to become. The new building was designed in the Richardsonian Romanesque style, a contemporary variation of Victorian architecture, and reflected New Albuquerque's prevailing passion for things thought to be up-to-date. What Hodgin Hall did not reflect was local culture. At that time, by definition *up-to-date* meant being borrowed from somewhere else. The railroad, and the promise of prosperity it brought with it, influenced this thinking. Hence, the first impression inscribed on the mesa was midwestern.

When William George Tight—a midwesterner—became UNM's third president in 1901, he brought with him a different vision. He believed that local buildings should not imitate styles borrowed from elsewhere, styles that were ill-suited to New Mexico. He believed in learning from the local building traditions and in applying what he learned to a distinctively regional style of architecture for the university. He perceived an opportunity to create a unique and attractive campus by celebrating this special regional identity.

President Tight launched a campaign to transform the University of New Mexico into a "pueblo on the mesa." He started with a new power plant, two dormitories, and a replica of a ceremonial kiva, which served as a hall for social gatherings. Soon the original red-brick Hodgin Hall stuck out like a sore thumb. Tight concluded that the building would have to be remodeled to look more like a Pueblo-style building and be consistent with the other buildings on campus. Off came the gables. On went earth-colored stucco to hide the brick exterior. Log vigas completed the transformation.

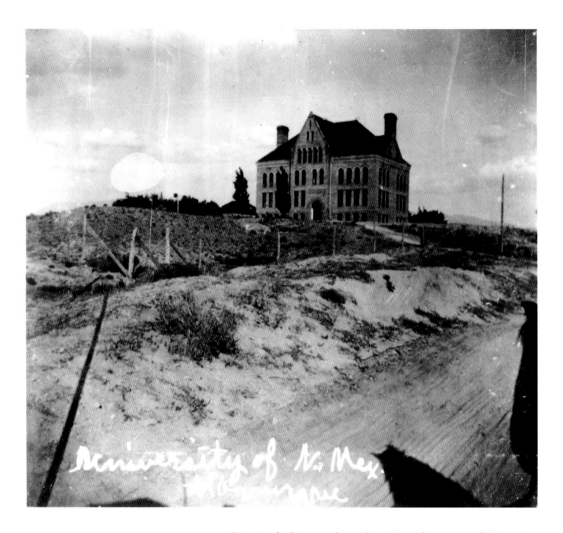

1905. This view looking northeast from Central Avenue and University Boulevard shows the University of New Mexico's Hodgin Hall in its original incarnation as a building designed in a midwestern style. Courtesy of the Albuquerque Museum, Gift of UNM Architecture Department, 1980.159.012.

1998. This same view shows Hodgin Hall as it was remodeled by UNM
president William George Tight in the early 1900s. The trees in front
of Hodgin Hall memorialize the former president as "Tight's Grove."
Photograph by Krista Elrick.

Citizens of New Albuquerque criticized the remodel of Hodgin Hall. One critic sneered, "If you are going to be consistent, the president and faculty should wear Indian blankets around their shoulders and feathered coverings on their heads" (Hooker 2000, 24). Charles Hodgin, the man for whom the building was named, came to President Tight's defense by pointing out that "people do not seem to think it odd to go back several thousand years to copy Greek architecture, but they could not tolerate what belonged to their own land" (Hooker 2000, 24). The point fell on deaf ears. The board of regents demanded President Tight's resignation.

Ironically, the Santa Fe Railway, which had introduced brick architecture from the Midwest to New Mexico as the epitome of prosperity and progress, gradually adopted what it perceived to be regional architecture in the construction of many of its own buildings as a way of luring tourists to the region. The Castañeda Hotel in Las Vegas, New Mexico; the Alvarado Hotel in Albuquerque; and La Posada in Winslow, Arizona, are examples. In doing so, the Santa Fe Railway recognized the economic advantage of promoting the Southwest's unique sense of place. Regional architecture was becoming respectable.

However, not until 1927, when the board of regents formally adopted the Pueblo style, was President Tight's vision of a campus with an architecture suited to the land and the cultural traditions of the region finally vindicated. In 1933 the university hired John Gaw Meem, a leading proponent of the Pueblo style, as the university architect.

Under Meem's guidance, the distinctive campus rooted in New Mexico's own cultural tradition, for which President Tight had fought and lost his job, became a reality.

By celebrating its identity as a special place with a distinctive cultural tradition, the university provides a model for enlightened development. It shows how Albuquerque can preserve its soul by remaining true to its history. Albuquerque is not Nashville. Or Milwaukee. Or Denver. Rather than merely imitating what has worked elsewhere, our elected officials should critically evaluate those examples in terms of what celebrates our own distinctive identity.

Further, the university points the way toward not borrowing the conventional pattern of development that has made most cities in America so sterile. It suggests an antidote to the homogenizing influence of corporate America by demonstrating the value of having a unique selling proposition to help differentiate Albuquerque in the market of desirable places to live.

2017 On September 11, 2015, the University of New Mexico issued a press release announcing that it had hired an ad agency in Pennsylvania to "reimagine how people define, view, and experience UNM . . . and to elevate UNM's relevance and reputation, increase enrollment, and build pride and loyalty among students, faculty, staff, alumni, and supporters." The decision to hire an out-of-state ad agency is similar to the decision in 1889 to design

Hodgin Hall, the first building on campus, in the Richardsonian Romanesque style. Both decisions reflect a timid mindset based on the mistaken belief that "up-to-date" and successful means being borrowed from somewhere else. Rather than honoring local building traditions and celebrating a distinctively New Mexican style of architecture, the founders of the University of New Mexico initially chose to imitate styles imported from elsewhere that were ill-suited to local conditions. Rather than building UNM's reputation on its own intrinsic regional merit, UNM's current leadership believes it can somehow build UNM's reputation by purchasing an expensive out-of-state–produced ad campaign.

We live in an age of appearances. The perception of substance is as important as the substance itself—at least over the short term. As Marshall McLuhan predicted, the medium has indeed become the message. In this larger context, it is not surprising that UNM would hire an ad agency to improve its image. But we expect more from our institutions of higher learning. We expect them to elevate the public discourse by exemplifying the highest ideals of society, not by reflecting the hyped marketing instincts of our business culture. Rather than being shaped by popular culture, we expect our universities to help shape popular culture by demonstrating an enlightened model of leadership.

No one likes buying something based on deceptive advertising—whether what is purchased is as trivial as shampoo or as profoundly important as a college education.

Reputations are earned, not bought. The $1.98 million of taxpayer money UNM's leadership decided to export to an out-of-state ad agency would have been far better spent on improving the university's educational product.

New Mexico is home to an unusually complex, diverse, and distinctive culture. The fact that the Pueblo Indians have continuously occupied their homeland along the Rio Grande for centuries—without having been forcibly relocated to some distant reservation—means their culture is uniquely vibrant and vital. The fact that the Hispanic occupation is almost as continuous—with a hiatus between 1680 and 1692 due to the Pueblo Revolt—means the Hispanic culture is also uniquely vibrant and vital. New Mexico's proximity to Mexico and all of Latin America only strengthens this Native American and Hispanic cultural vitality. The fact that two of the premier scientific laboratories in the United States are located in New Mexico means the scientific and technological culture is also uniquely vibrant and vital. The University of New Mexico could incorporate these unique regional cultural attributes into unique academic programs (the idea of the present as a legacy of New Mexico's past, energy efficiency, water conservation, sustainability, etc.) rather than trying to compete nationally in the same academic specialties in which UNM is doomed to be outspent. In commercial terms, these attributes are New Mexico's "unique selling proposition." The University of New Mexico should play to these strengths.

The decision to hire an out-of-state public relations

firm to improve its image rather than making the university the best it can be by celebrating our state's strengths reflects poorly on UNM's leadership and underscores the urgent need to change the way the university's overseers are selected. As the system currently operates, New Mexico's governor appoints UNM's regents with the consent of the senate. Becoming a regent is viewed as a prestigious appointment. The desirability of the appointment is leveraged by the governor as a political plum that is given to reward political support, usually in the form of significant financial contributions. As a result, the criterion for appointing the regents is based on the capacity to contribute. Although the regents who are appointed may be well intentioned, they tend to be people who are politically connected and wealthy. The problem with this system is that it weakens the leadership of the university. Money can't buy wisdom or good judgment. All it can buy is a megaphone, which is not the same as having something worthwhile to say. The system of meritocracy that allows the best ideas and best thinkers to rise to the top of our society is undermined. Rather than promote the building of better mousetraps, this unfortunate system for choosing the regents allows advertising to sell us inferior goods.

UNM's board of regents consists of seven members with staggered terms of six years each except for the student regent who is appointed for a two-year term. According to UNM (2017), "the Board's power to govern the University includes fiduciary responsibility for the assets and programs of the University, establishment of goals and policies to guide the University, and oversight of the functioning of the University. The Board vests responsibility for the operation and management of the University in the President of the University." Of the twenty-seven nonstudent regents who have been appointed over the past twenty-six years by governors of both major parties (Bruce King, Gary Johnson, Bill Richardson, and Susana Martinez), twenty regents, or 74 percent, have been attorneys or businesspeople, only three regents have been from the field of science (Sandia or Los Alamos National Laboratories), two regents have been retired military, one regent had been a nurse, and one regent had been a government tax policy specialist. It is not surprising that lawyers, the most politically active and therefore the most politically connected profession, would make up the majority of regents, given how the regents are appointed. Nor is it surprising that businesspeople are also disproportionately represented as regents, given the influence of money on politics. What is surprising is that, as a society, we would relinquish the governance of our state's most important institution to such a narrow spectrum of citizens.

We live in an age of specialization, and this has resulted in the habit of thinking in silos. The problem with such a high percentage of attorneys being appointed to the board of regents is that it creates a specialized silo in the governance of the university when what is needed is a broad understanding of the big picture. Like any profession, attorneys view the world through a lens that is particular to the

constructs of their profession. This is what they are taught in law school. The narrow focus of this lens too often prevents them from seeing the big picture. The governance of the university suffers from a legal strain of tunnel vision. It would be just the same if the majority of regents were engineers or architects, businesspeople or accountants, journalists or historians, biologists or doctors, nurses or teachers. The point is, to strengthen the leadership of the university, we need to diversify the lenses through which the university is governed by diversifying the professional makeup of the regents.

What if, in additional to lawyers and businesspeople, we had professional educators on the board of regents? Professional scientists? Artists? Medical doctors? Would these diverse vocational viewpoints improve the university's leadership? Would a merit-based system for selecting regents from these diverse vocations attract better administrators, better faculty, and better students to the University of New Mexico? To change how the regents are selected and appointed would require an amendment to the New Mexico Constitution. This would be a huge undertaking. It may be worth trying. The economic, technological, and cultural impacts the university has on Albuquerque and on New Mexico are too important to continue to allow the regents of the university to be appointed on the basis of political connections rather than on the basis of merit.

1890. Pauline Borradaile stands at the southeast corner of Old Town Plaza, with the plaza and San Felipe de Neri Church in the background. Courtesy of the Albuquerque Museum, Gift of John Colligan, 1989.017.050.

1998. Jack Colligan, in the same spot, holds the 1890 photograph of
his aunt. Photograph by Krista Elrick.

ANCESTORS
Mark C. Childs

1998 After a bitter defeat, the Athenian general Nicias rallied his soldiers, proclaiming, "You are yourselves the town, wherever you choose to settle. . . . It is the men that make the city, not the walls and ships without them" (Kostof 1991, 36).

Spiro Kostof (1991), an architectural historian, used Nicias's speech to introduce two concepts of what makes a city: the Latin term *urbanitas* denotes the idea that a city is a collection of structures and spaces, a material work of art; *civitas* reflects Nicias's point—the city is a righteous assembly of citizens. Urban form, urbanitas, and civic structure, civitas, are intertwined.

Jack Colligan, shown in the 1998 photo, is the nephew of Pauline Borradaile, shown in the 1890 photo. Borradaile grew up as a member of the extended Armijo family that owned many of the houses around Old Town Plaza.

Old Town in her youth was called the "West End," but it was not part of the incorporated city of Albuquerque. During the Bicycle Age—the 1880s and 1890s—it was an active commercial and civic center losing ground to the booming New Town.

The buildings were in transition from a vernacular adobe style to "Adobe Victorian." Flat-roof buildings were adorned with gabled and patterned shingle roofs, and the turned columns of *portales* were replaced with square posts and Victorian gingerbread scrollwork.

The county courthouse and the territorial fairgrounds bordered Old Town, but many businesses were moving away to New Town. By World War I, Old Town had lost many of its commercial and civic functions but retained its strength as a Hispanic social, religious, and neighborhood center.

According to the historic nomination report for Old Town, in the 1920s and 1930s the "Greenwich Village

Group," a small group of artists, writers, and architectural aficionados, took an interest in the character of Old Town. The initial wave of "historic" renovations and remodels occurred in this era. But it wasn't until after World War II that tourism began to have a decided impact on the buildings.

In 1949 Old Town was annexed to the City of Albuquerque. In the following decades, various regulations of its historic character were developed, and the current cornucopia of tourist businesses arose. In the lives of two generations, both the civic structure and urban character of Old Town have been radically transformed.

Yet for all the criticism that has been made of the touristification of the plaza, a genuine thread of continuity and coherence has persisted.

Colligan can return to the spot where his aunt was photographed as a child and imagine a bit of her life. The San Felipe de Neri Church seen in the background of the 1890 photo remains an active church. The plaza (albeit now with a park in it) and streets retain the urban character of a Spanish New World town. Local artistic traditions have persisted and adapted to the cultural economy of the twenty-first century. Traces of various historic and revival building styles remain. Personal memories and family stories still have a place to take root.

The incremental transformation of the West End into Old Town has allowed us to retain a sense of place that wholesale urban renewal would have destroyed. There remains a storyline, a continuity of uses and architectural styles that ties us to the past and promises to connect us to the future.

The balance between a place's ability to adapt, yet keep a sense of continuity, is, I believe, critical to the health of our cities and civilization. If, for the sake of strong continuity, we attempt to stop architectural change, then we risk making a living part of the city into a museum of itself. On the other hand, if, for the sake of worshiping the new, we forsake maintaining continuity with the past, then we risk losing our memory, our connection to place, and a bit of hard-won wisdom about how to live in a place.

The touristifiction of the plaza has not struck the best balance between change and continuity, but it is better than if the plaza had become a museum or if wholesale urban renewal had razed the plaza and put in a parking lot.

The high tide of trinket tourism has perhaps already begun to recede. I believe the upcoming generations are showing signs of preferring to live in places rather than "tour" them. As this happens the civic and economic structure of Old Town will need to again transform.

I hope this change will be balanced with a robust sense of history that includes the successive generations of the plaza—the various phases of the colonial period, the Bicycle Era West End of Pauline's youth, the acequia-watered Victory Gardens of World War I, the Greenwich Village period *and* the tourist era.

I hope it will strike a balance that reflects not simply the chronology of Old Town's buildings but also the living wisdom of the generations who lived and worked on the plaza.

ACEQUIA CULTURE AND COMMUNITY SPIRIT
Anthony Anella

1998 When Albuquerque was founded in 1706, the Spanish colonists brought with them irrigation practices common to the arid regions of Spain that were based on Arabic customs learned during seven centuries of Moorish occupation. *Acequia* is the Spanish word for irrigation canal; it derives from the Arabic word *as-saquiya* for water carrier. The early Spanish settlers modified these customs based on the influence of Pueblo Indian farmers to fit the local conditions. In a remarkable confluence of culture and history, Albuquerque's ditch system reflects Moorish, Spanish, and Pueblo Indian influence.

In *Acequia Culture: Water, Land, and Community in the Southwest* José A. Rivera (1998, xx) points out that "as physical systems, acequias literally created community places by demarcating the boundaries of fruitful settlement, altering and channeling the stream flow to set the land-use capacities of the community." Acequias not only created community places but also created a sense of community. As Rivera writes, "As a physical system, the acequia has required communal upkeep and operations, but beyond this dimension, it has also bonded the community through self-help mutualism, governance, shared values, and traditions that formed a distinctive regional culture" (1998, xxiii). The historic acequia system that runs through Albuquerque fosters a shared sense of place that is an integral part of our collective identity and community spirit. Even though the agricultural purpose for the acequias is disappearing, they still provide a common neighborhood thread as well as a connection to the land and our history that distinguishes Albuquerque as a special place to live.

In 1960 the population of Albuquerque was 201,000. In 1997 the population was 411,994: an increase of over 100 percent in less than forty years. During this same period an acre of valley land appreciated from $5,000 to over $100,000. As a consequence of the rapidly growing

population, the land has acquired a development value that exceeds its value as farmland. During the last forty years the Bureau of Reclamation estimates that Albuquerque has lost 8,900 acres of farmland to urban development nearly half of the 20,400 acres under cultivation in 1955 when agriculture in Albuquerque was at its peak.

Ironically, converting farmland into subdivisions also minimizes the value of the developed land as a long-term investment by undermining the rural character that makes the valley an attractive place to live. Unfortunately, there is no easy solution to this dilemma. However, there is a way of perpetuating the connection to Albuquerque's history and agricultural heritage as well as strengthening its sense of place and community spirit. The acequias provide a common ground between farmland conservation and the pressures of urbanization.

What distinguishes the valley is the irrigated quality of the landscape. In the arid Southwest people are attracted to places that are green and growing. In addition to irrigating what farmland remains, the acequia system also sustains a canopy of cottonwoods, Russian olives, Siberian elms, and other plants that grow along its ditch banks. It provides hundreds of miles of shady trails that are already part of an existing common property network that does not have to be purchased as a public space amenity. Access to this network of trails enhances the value of adjacent private property.

In addition to irrigating what farmland remains, the acequia system also expands the riparian habitat for plants and wildlife from the narrow confines of the river's edge to the broad expanse of its otherwise arid floodplain. In a recent study the Bureau of Reclamation found that the acequias and the land that they irrigate account for half of the annual recharge of the city's aquifer, about 31,000 acre-feet, or as much as the Rio Grande itself.

Perhaps most important of all, the historic acequia system, as a legacy of our agriculture heritage, provides a compelling model for urban water resource management that emphasizes responsibility to the entire community.

2017

Acequias are metaphors for environmental optimism. By "demarcating the boundaries of fruitful settlement" and setting "the land-use capacities of the community" on a local scale, they provide a humble but profound model for how we might work more gracefully within the limits of nature on a global scale. They balance just the right amount of engineering muscle with just the right amount of artistic finesse. As man-made channels that follow the natural contours of the land, they work with the earth, not against it. As man-made conveyors of rainfall and snow-melt, they work with the hydrologic cycle for the benefit of irrigated farmland. Acequias treat nature as an ally, not an enemy. They provide a glimpse of how such an alliance can preserve what Aldo Leopold described in his land ethic as the "integrity, stability, and beauty" of life on our planet.

Acequias are also metaphors for cultural optimism. On a local scale they demonstrate the beneficial outcome that

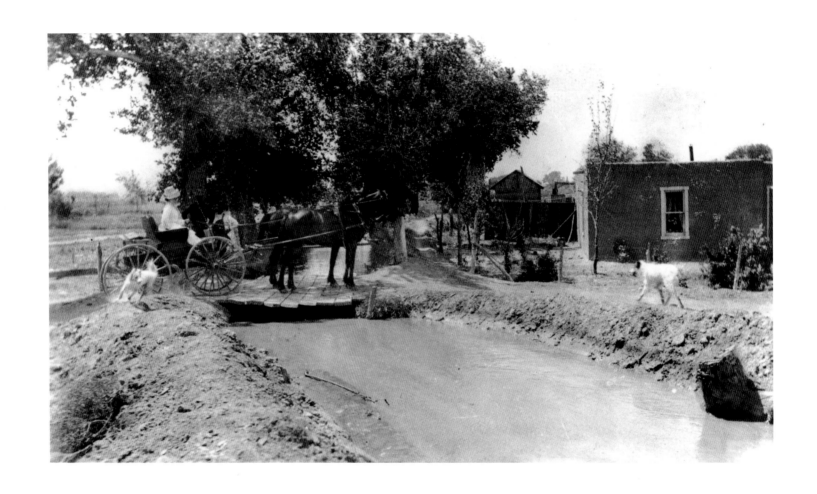

1911. This photograph is of an Albuquerque irrigation ditch. The exact location of the site is unknown. Courtesy of the Albuquerque Museum, Gift of Howard Bryant, 1989.006.006.

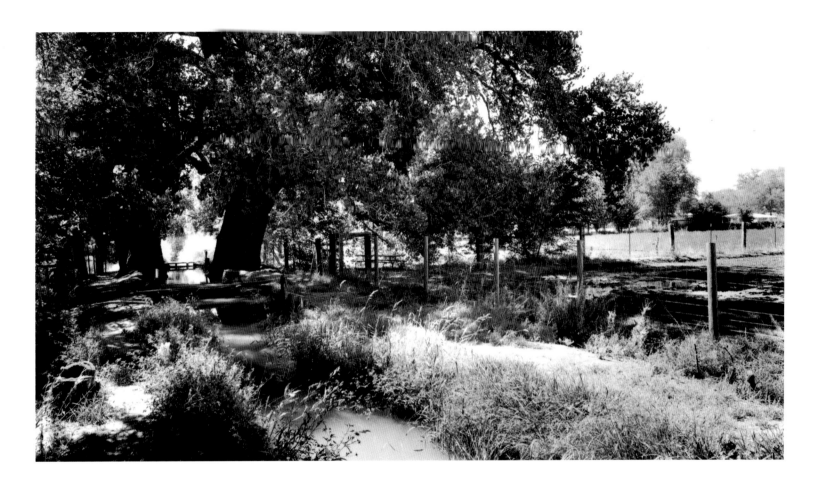

1998. The irrigation ditch in this contemporary photo bears a remarkable resemblance to the one in the historic photograph. But it is the one photograph in the Albuquerque rephotography series that may not be an exact match with the historic photograph. It shows the acequia north of Pueblo Solano, between Fourth Street and Guadalupe Trail on the east side of the Rio Grande in Albuquerque's North Valley. Photograph by Krista Elrick.

results from sharing a task that is beyond the capability of any one individual, and that can only be completed through community collaboration. The climate is unpredictable in the arid Southwest. Drought is common. Acequias demonstrate a system of water sharing that allows agriculture to adapt to fluctuating patterns of precipitation. On a global scale acequias provide a humble but profound model for how human civilization might work together to share the responsibility of adapting to climate change. Most profoundly of all, acequias are metaphors for querencia, the Spanish word meaning love of place through knowledge of the local environment. As grassroots institutions where people elect their own officers, write their own rules, establish their own goals, and divide the tasks, or *tareas*, among themselves, acequias demonstrate a mutual querencia based on a shared self-interest in caring for the land. As socio-ecological systems they provide a glimpse at a hopeful way out of humanity's environmental predicament.

Hillel said, "If I am not for myself, who will be for me? Yet, if I am for myself only, what am I?"

Pope Francis wrote, "Because all creatures are connected, each must be cherished with love and respect, for all of us as living creatures are dependent on one another."

Aldo Leopold wrote, "That land is a community is the basic concept of ecology, but that land is to be loved and respected is an extension of ethics."

Dr. Seuss's Lorax said, "Unless someone like you cares a whole awful lot, nothing is going to get better. It's not."

As metaphors, acequias show how we can come together in caring for our common home. They point the way toward how we might recapture the hearts and minds of the world—especially the world's young people, a generation faced with prospects of environmental degradation and economic inequality—by demonstrating we have the collective wisdom and will to come together to fundamentally change our relationship with nature and the human constructs of the past that are no longer working. The environmental crisis is an existential dilemma that derives from whether we perceive ourselves to be part of nature or separate from nature. The conventional way we conduct business—how our accounting systems conveniently externalize the environmental costs of human enterprise—is an example of humans acting on the perception of somehow being separate from rather than part of nature. Another example is the way we draw rectilinear lines on a map to arbitrarily impose boundaries on the land without regard for the ecologic reality on the ground. The fact is, the only accounting system that matters is the one that measures the health of our planet. The fact is, environmental degradation knows no political boundaries. The radioactivity from the Chernobyl nuclear disaster was carried by the wind into Western Europe and beyond, and what happens to the Brazilian rain forest will affect the entire planet. The environmental crisis is not simply a technical problem. It can't be solved by scientists or engineers alone, and it won't be addressed by politicians until there is a bottom-up citizen movement in support of doing so.

Acequias can help inspire humanity in this regard.

LEARNING FROM LOS GRIEGOS
Mark C. Childs

1998 The Laws of the Indies likely established the first "zoning code" in America.

In 1573 the Spanish Crown assembled the laws that pertained to the founding and design of New World cities into the Laws of the Indies. The formation of public space and the establishment of civic relationships were central concerns of the laws. Perhaps we could better call it a "settlement code."

Santa Fe's plaza, with the governor's palace on one edge and the church up a rise to the east of the plaza, is a robust example of a Laws of the Indies plaza. Homes in these settlements clustered along a grid of streets around the plaza, and fields were on the outskirts.

The plaza shown in the 1885 photograph of Albuquerque's Los Griegos settlement and indeed the entire form of Los Griegos differs from the law's prescriptions.

In 1708 Juan Griego was granted a sliver of land that stretched from the Rio Grande to the Sandia Mountains.

This long grant provided access to the river and farming and grazing lands.

The settlement was built among the farmlands. In the early 1800s Los Griegos was a small agricultural settlement of about twenty-five homes that stretched along a road between two main acequias. Houses sat next to the road, and their fields stretched behind them to local ditches. By 1885 there were about three hundred people in Los Griegos.

Often as these farmhouses were passed from generation to generation, the fields were divided. Because access to the acequia is a necessity for farming, the fields were sliced into long lots with a short frontage to the ditch. These long lots, or *lineas*, are to this day a distinctive feature of New Mexico's agricultural valleys.

Evidence suggests that the plaza in Los Griegos was essentially a wide portion of the road in front of the church, but it was the center of town. As the stagecoach in

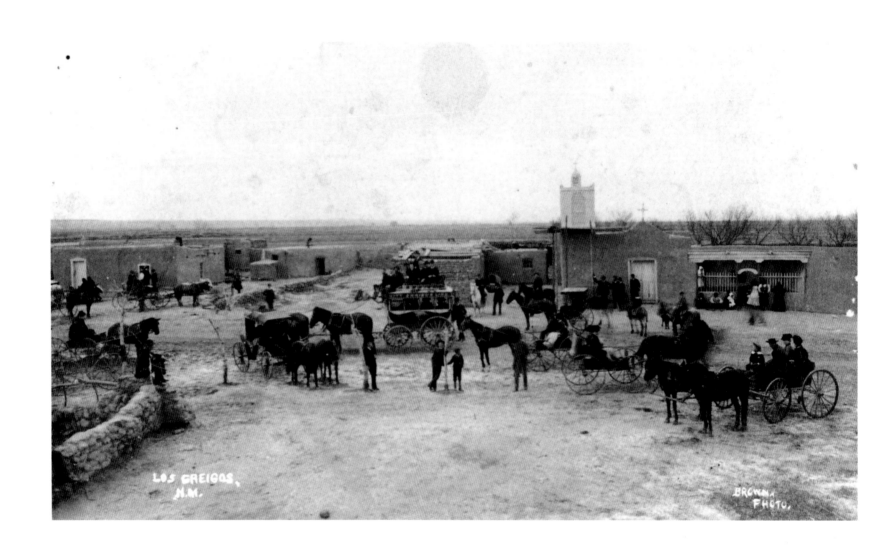

LOS GREIGOS,
N.M.

BROWN.
FHOTO.

1885. A stagecoach bound for Albuquerque waits at Los Griegos Plaza. The church at Los Griegos is on the right. Courtesy of the Albuquerque Museum, 1978.650.075.

1998. The church as seen in 1998 was remodeled extensively into
a private residence. The plaza, located on Griegos Road just east of
Rio Grande Boulevard, is private property that frequently hosts a
Christmas tree lot. Photograph by Krista Elrick.

1897. Map of the Elena Gallegos Land Grant. Courtesy of the Center for Southwest Research.

the 1885 photograph suggests, Los Griegos was also part of a larger community. The coach connected Los Griegos to other valley villages—Los Ranchos, Los Candelarias, and Albuquerque.

Albuquerque was where people went to trade, to talk, and to be part of society. Creating public space at the small village scale does not eliminate the need for larger scales of fellowship.

Although the linear settlement of Los Griegos differed from the prescriptions of the Laws of the Indies, it did adapt the spirit of the laws to local conditions. The homes were not simply a collection of independent houses, but rather parts of a village. The church and plaza, the street and acequia system knit the buildings together into a civic place. Los Griegos was an urban farming community, unlike the isolated ranches and suburban developments we often build today.

One of the hot urban planning concepts of the 1990s was the "urban village." Urban villages are neighborhoods of a few thousand people within a larger city that include not only a collection of houses but also civic places such as schools, community centers, cafés, and plazas.

Many of the great cities of the world have this pattern. For example, in addition to the great plaza of San Marco, Venice boasts numerous neighborhood plazas and pedestrian streets that are civic spaces. Since 1988 citizens of emerging urban villages in Seattle, Washington, can request city funds for community-driven projects that enhance and strengthen their own neighborhoods. The famous Fremont Troll benefited from these funds, as have numerous street tree and community garden projects.

Los Griegos and her sister villages suggest that within urban villages of a few thousand people there can be smaller neighborhood villages—places as small as twenty-five homes with their own plazas.

Los Griegos adapted the Laws of the Indies to its time and circumstances but retained the wisdom that public spaces are critical features of a community. Imagine if we could adapt the wisdom of Los Griegos to our time.

From time to time students at the University of New Mexico's School of Architecture and Planning have studied Los Griegos's interaction of form and community. Cynthia Sue Bruce's (1982) thesis won a nomination of Los Griegos to the National Register of Historic Places that not only helped bring economic resources to the preservation of buildings but also brought attention to the value of these small settlements. Cory Greenfields's (1998) thesis illustrates an alternative to a modern, purely residential cul-de-sac development adjacent to Los Griegos. Based on today's economy and society, Cory's project reestablishes the historic relationship between community and land.

Imagine if this learning spread into the everyday business of "development." Trends toward home offices, home schooling, and mother-in-law apartments mean that neighborhoods are no longer the empty bedroom precincts of the recent past. As more people stay home, our residential districts must again transform into villages with local public spaces and services.

Our cul-de-sacs of twenty-five homes could become villages—not walled collections of bedrooms and garages keeping the world at bay, but homes that share civic spaces with each other and with other neighborhoods.

Imagine if we could learn from Los Griegos.

2017

"Istanbul is wonder upon wonder, sedimented wonder, metamorphic cross-bedded wonder. You can't plant a row of beans without turning up some saint or Sufi. At some point every country realizes it must eat its history. Romans ate Greeks; Byzantines ate Romans; Ottomans ate Byzantines; Turks ate Ottomans. The EU eats everything," Ian McDonald (2010, 78–79) wrote in *The Dervish House*. McDonald's novel rests on the complex interweaving of these layers of history that makes Istanbul (a.k.a. Stamboul, Constantinople, Byzantium, Lygos, the Queen of Cities). The question is, what should be understood by McDonald's metaphoric term "eat"? I believe McDonald captured a dominant conception of how we should relate to the past, but is "eating" the metaphor we wish to guide how we treat earlier patterns of settlement? Must we devour our past, plow it under, and only on occasion rediscover its potsherds? In what ways can and should an era acknowledge, respect, honor, and learn from the constructions of earlier eras?

In *Shining River, Precious Land: An Oral History of Albuquerque's North Valley* Kathryn Sargeant and Mary Davis note that "the oldest archaeological site so far discovered on the valley floor dates back 2,500 years. Older sites have no doubt been covered or erased by the floods of the river" (1986, 13). Captain Castañeda of the Coronado expedition "describes twelve large Indian villages of the Tiguex Province [roughly between modern Bernalillo and Isleta] built on both sides of the river" (Sargeant and Davis 1986, 13). The ruins and reconstructions of Kuaua Pueblo at the Coronado Historic Site, potsherds scattered in the river-bottom soil, and the reuse of sites for subsequent settlements are

what remain of these Tiguex villages. Establishing an historic monument is one means of attempting to acknowledge and perhaps learn from earlier communities.

The 1897 map of the Elena Gallegos Land Grant shows six Spanish settlements in the North Valley—Los Griegos, Los Montaños, Los Gallegos, Los Ranchos, El Rancho, and Alameda. Los Duranes and Los Candelarias were south of the map, and there were farms between these village centers.

As I discussed above, Los Griegos and these other villages could provide a model for future "urban villages." Since 1999 housing compounds have filled what once were the irrigated fields in back of village houses. The old church is a private house, and the memory of the plaza lives only as a Christmas tree lot. Perhaps a remodel of the Griegos Library and its parking lot could reestablish a community plaza, and perhaps home offices and small businesses will yet enliven and diversify the street, but the richness of the historic pattern has been nibbled away.

The frequently flooding Rio Grande removed much of the other settlements. Los Montaños, Los Gallegos, Los Ranchos, and El Rancho survive primarily as place names. Old Alameda, which was founded in 1710 on the site of an older Tiwa pueblo, also was taken by the river in the flood of 1903: "The river moved from the eastern to the western edge of its floodplain, taking everything with it—adobe church and house, orchards, vineyards, fields, and one of the routes of El Camino Real de Tierra Adentro" (Lamadrid and Gurulé 2013).

On January 28, 2013, a remarkable event of acknowledgment, respect, and honor was held at the Nativity of the Blessed Virgin Mary Church in the current community of Alameda. In 2003 an infrastructure project hit an all-but-forgotten graveyard. The work had uncovered the earthly remains of 123 people who had been buried in the *camposanto* of the old Immaculada Concepción Church in Old Alameda. In a daylong community event these people were celebrated at the new Alameda church and reinterred at the San Carlos Camposanto. This religious and community event provides another model for our relationship to earlier settlements—a continuity of story and enacted respect.

IMAGINE A CITY THAT REMEMBERS
Anthony Anella

1998 Preservation of our cultural heritage along with conservation of our natural resources can only be achieved if people choose to care. This has been the point of the rephotographic survey project: to contrast a series of historic and contemporary photographs of the same places in Albuquerque as a way of fostering affection for this city we collectively call home.

To be consistent with the series, the contemporary photograph made in 1998 should show a nearly empty gravel parking lot. Twenty-nine years ago, on January 2, 1970, the Alvarado Hotel closed its doors. Despite the efforts of local groups to save the landmark, a month later the Santa Fe Railway demolished what had been the social center of Albuquerque, leaving an unsightly hole in downtown and a gaping wound in our civic pride.

Instead of the existing gravel parking lot, the contemporary photograph is of a model of a new building that is to be built on the site of the old Alvarado near First Street and Central Avenue. The "Alvarado Intermodal Transportation Center" is designed to look like the old Alvarado.

The center will become the transportation hub for Albuquerque by linking the city's buses and trolleys with Greyhound coaches, Amtrak trains, tour buses, taxis, and possibly a future light rail system. If all goes as planned, the center will make using public transportation easier and friendlier, which will further the city's goal of getting more people to use it.

It seems historically fitting that the planned transportation center will also serve to anchor the revitalization of downtown. The demise of the old Alvarado and the decline of downtown as a social center had to do with the changing economics of transportation nearly thirty years ago. The expansion of trucking and air freight service crippled one side of the railroad business; the loss of passenger traffic to automobiles and planes undermined the other. Coinciding with the decline in the railroad was a surge in publicly

1930. This view looking northwest near Central Avenue and First Street shows the Santa Fe Railway depot, with the former Alvarado Hotel designed by Charles F. Whittlesey in the background. The Alvarado Hotel was torn down in the early 1970s. Courtesy of the Albuquerque Museum, Ward Hicks Collection, Gift of John Airy, 1982.180.211.

1998. In 1998 the site of the former Alvarado Hotel was a gravel parking lot. In this photograph a model by the DPS architecture firm depicts what is imagined to replace the old Alvarado Hotel: a new transportation center that recalls the design of the historic hotel. In 2017 the building portrayed by the model has been built and is occupied by the Albuquerque Transit Department. Photograph by Krista Elrick.

funded freeway construction. The alignments for Interstate 25 and Interstate 40 began in 1956; the interchange where the two cross—the "Big I"—was completed ten years later. This new highway complex facilitated access to and from the suburbs while at the same time bypassed downtown. Central Avenue—old Route 66—fell into an economic slump. By the late 1960s the area around the Alvarado had become a dysfunctional part of the city.

Function, in our society, is most often defined in economic terms. A building has to earn its keep to survive. Only recently have we begun to accept the idea that function might also be defined as providing beauty in our everyday lives or as providing a sense of place and identity that distinguishes us from a built American landscape that is becoming increasingly homogenized. Most of all we are beginning to realize that function might also be defined as providing a soul-nourishing sense of continuity in a rapidly changing world.

So what does it mean for Albuquerque to have mustered the political and economic will to create a transportation center in the image of the old Alvarado, nearly thirty years after the original building's demise? That we need places like the Alvarado—even if only imaginary—as a point of reference, not just to tell us about the past but also to provide perspective on the present and on the future. That by not saying good-bye to our past, we can learn to celebrate our city for what it is and what we want it to become.

2017 Re-creating the Alvarado represents an inflection point in Albuquerque's sense of itself. Refusing to let others tell our story for us is a powerful affirmation of Albuquerque. The demise of the old Alvarado Hotel and the decline of downtown Albuquerque as a social center had to do with forces outside our community. Urban renewal, the policy that mistakenly tore down so much of downtown Albuquerque, was a national phenomenon. So was the new national interstate highway system. I-25 and I-40, which bypassed downtown Albuquerque, made possible the development of Winrock, a regional shopping mall located along the freeway. This siphoned business away from downtown. Named for its out-of-state owner, Winthrop Rockefeller, Winrock was developed as a joint venture with the University of New Mexico and opened in 1961. Downtown's Fedway Department Store with its rooftop parking lot and escalator down into the store closed that same year and moved to Winrock. Paris Shoes, a locally owned retail success story and fixture of downtown's main street for many years, also moved to Winrock. Downtown fell into an economic slump. Fast-forward forty years and—in an ironic twist—the ABQ Uptown shopping center, just north of Winrock, was developed to *re-create* the outdoor urban shopping experience that we could have had more authentically in downtown Albuquerque!

This irony raises a question: Would Albuquerque have

had the community vision and strength of character to resist such wrongheaded national trends had it learned to honor its historical identity sooner? Salt Lake City offers a hopeful example of how this might have been possible. The Mormon Church's central presence in downtown Salt Lake City ensured the primacy of that place as the spiritual, social, and economic hub of that community. There was no way the Mormon Church was going to allow Salt Lake City's downtown to falter. It had too much invested in downtown Salt Lake City real estate. As a result, among other things, downtown Salt Lake City has its own regional shopping mall. Significantly, and even more to the point, downtown Salt Lake City also has its own museum that honors the history of the Mormon pioneers who built downtown Salt Lake City. By honoring the impressive accomplishments of Mormon endeavor during the first 150 years of Mormon history, the leaders of the Mormon Church made sure Salt Lake City did not lose its sense of itself as a place that matters. Thanks in large part to the Mormon Church, Salt Lake City had the community vision and strength of character to resist the otherwise prevailing national trends that were motivated by outside financial interests. As a result, Salt Lake City kept its center.

What is there to keep Albuquerque's center? We are a community made up of many churches. Not one of those churches plays the dominant role in Albuquerque that the Mormon Church plays in Salt Lake City. In the absence of a dominant religious worldview, Albuquerque must rely on its secular traditions and institutions to hold its center: the Gathering of Nations Pow Wow, annual Founders Day Fiesta, Albuquerque International Balloon Fiesta, New Mexico State Fair, ¡Globalquerque!, Outpost Performance Space, Chatter, University of New Mexico, Central New Mexico Community College, Albuquerque Public Schools, Albuquerque Museum, National Hispanic Cultural Center, Indian Pueblo Cultural Center, Explora Science Center and Children's Museum, and Albuquerque BioPark, to name just a few (with apologies to the others). Whether we share a single religious worldview or not, the fact is, we are all in this together. For our children to want to live in Albuquerque for its quality of life, and for our children to be able to live in Albuquerque for the career opportunities it affords, we need to pull together. United, Albuquerque stands. Divided, Albuquerque falls.

Ox carts and Model A's, lowriders and Cadillacs: if there is one physical place that holds our center, it is the intersection of Fourth Street (the historic Camino Real) and Central Avenue (the historic Route 66). Fourth and Central holds Albuquerque's center for two contradictory reasons. First, more than any other place, Fourth and Central symbolizes the place where the history of Hispano-Albuquerque and the history of Anglo-Albuquerque come together. Second, Fourth and Central also symbolizes the place where Hispano-Albuquerque and Anglo-Albuquerque pull

apart. Fourth and Central is at once the epicenter of a centrifugal cultural force that spins the northeast heights so far away from the South Valley, and the cultural crossroads where the attraction of opposites binds us together. It is this tension that sparks Albuquerque's genius.

Big Macs and green chile cheeseburgers: what makes Albuquerque special is its cultural quirkiness. We are not Salt Lake City or Denver or Amarillo or Phoenix. We should embrace this fact, celebrate who we are and not try to be something we are not. Business models that work somewhere else may not necessarily work here. So what? The franchise culture that homogenizes the United States is based on a false premise and a lack of creativity. One size does not fit all. Franchises seduce the bankers into believing that, if it worked somewhere else, surely it will work here. The key to Albuquerque's creative success is finding business models that work here because they are rooted here.

By honoring Albuquerque's history—by remembering our past—we cultivate respect for our present and our future. Imagining Albuquerque as a city that remembers is to imagine Albuquerque as a city that respects itself as a place that matters.

TELLING CITY STORIES
Mark C. Childs

1998 Every city inspires ten million pictures, and every picture houses one thousand stories. We hope that in this series we have managed to select a few of Albuquerque's engaging stories. Moreover, we hope the series has added to the discussion of how Albuquerque can prosper, become a more delightful place, and remain true to itself.

The most complex part of this work has been selecting what stories to tell.

Each selection left something out. Using historic photographs eliminated the history of places made before the invention of photography and many places of the poor that were rarely photographed.

In our rephotography we have attempted to be accurate as to the exact location and time of day. But other things, such as whether to wait for a car to move or people to walk into the picture, were judgments based on the stories we wished to tell.

The facts we have gathered are accurate to the best of our knowledge, but the stories we told with those facts frequently evolved in the research and writing. I selected at least one historical photograph thinking I would write about something that wasn't even mentioned in the final draft. But this art of selection is always part and parcel of writing. Writers—even, and perhaps particularly, newspaper writers—must choose their stories.

Even a minor aspect of how writers work can shape the stories they tell. Take, for example, the location of a newspaper office.

A reporter or editor runs into people on the way to work or at lunch who suggest stories or simply help the writer understand what is on "the public's mind." If the newsroom is downtown, the reporter's lunch crowd is most likely downtown denizens who are knowledgeable and interested in downtown events. When downtown is

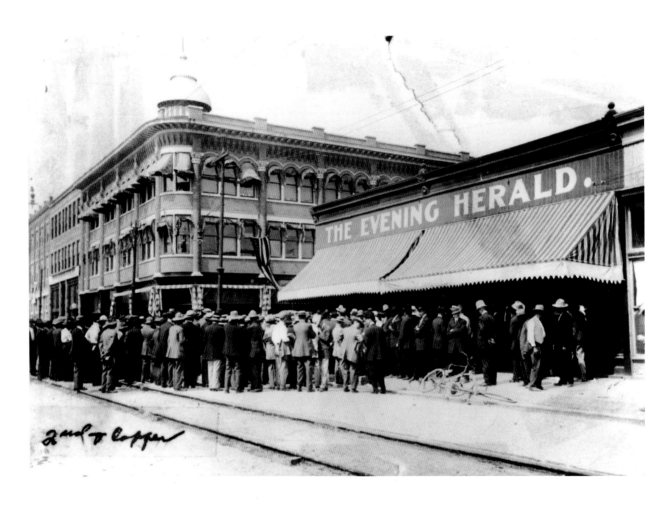

1915. This photo shows the view, looking northeast, of a gathering outside the *Evening Herald*'s offices at Second and Copper. Note the newspaper's large awning over the sidewalk, which must have given welcomed shade to pedestrians. The streetcar tracks in the foreground ran up Second to New York Avenue, now Lomas, and then up Twelfth to the sawmill. Courtesy of the Albuquerque Museum, Gift of Harvey Caplin, 1981.020.011.

110

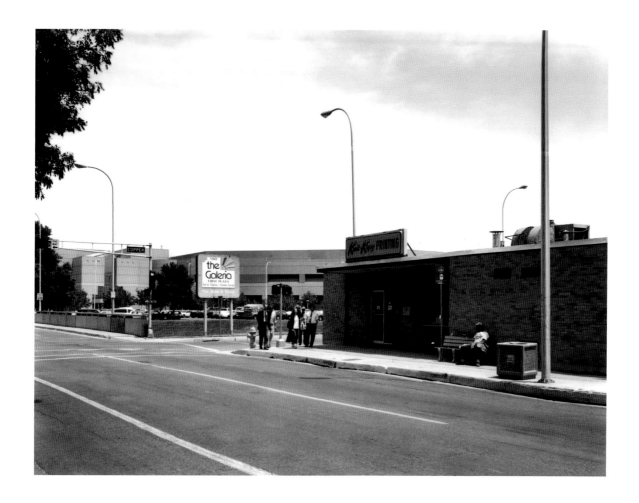

1999. This photo of the same corner in 1999 reveals much less urban
vigor than the earlier photo. In 2017 this view is much the same.
Photograph by Krista Elrick.

the center of commercial, governmental, and civic activity, then a downtown lunch crowd bias makes sense—news reporters should hang out where the news is.

Since 1880, when New Town (now downtown) was built two miles from the Old Town Plaza, Albuquerque has had multiple, competing centers.

Downtown and Old Town vied for civic centrality, fighting over the locations of post offices, courthouses, and other civic structures. In the early years of this battle newspaper offices were to be found in both Old and New Town, but as downtown gained ascendancy, newsrooms moved downtown.

Before the 1930s the newspaper business in Albuquerque was volatile, with papers going in and out of business, changing names, merging, and moving.

The *Evening Herald* shown in the 1915 photograph existed under that name from 1914 to 1922. It was the descendant of the 1909 *Albuquerque Daily Tribune*. In 1922 it became the *Albuquerque Herald* and then the *Albuquerque Journal*. In 1933 the *Albuquerque Tribune* (founded in 1922 as *Magee's Independent*) and the *Albuquerque Journal* set up a joint shop downtown at 424 West Gold and began their long domination of the market.

Beginning in the 1960s, Albuquerque, like many other western cities, began to sprout new proto-downtowns based on easy automobile access. Of the many dreams of centers that were begun, Uptown, the Journal Center, and Cottonwood have taken root.

These new centers of business drew vitality from downtown. In the 1980s the *Tribune* and *Journal* moved out of downtown. In a June 14, 1985, *Tribune* column, Bart Ripp described downtown as a sinking ship that he, as part of the newsroom, was relieved to flee.

But the late twentieth-century decline of downtown was not an irrevocable sinking caused by an iceberg or other force of nature, but rather the decline was caused by the collective consequences of individual decisions.

The newspapers chose to act along the lines of Ripp's sinking-ship story rather than the counterpoint view the *Tribune*'s Jack Ehn expressed in the same column—that downtown is a noble place deserving our support. By acting on the sinking-ship storyline, the papers helped make it a reality.

The stories we choose to tell, the way we see and marshal "the facts," can guide the way we act. Tony Anella and I hope we have told stories that inspire us all to learn from the city's past but more importantly to consider the consequences of our individual actions and to build a more delightful and prosperous city. Moreover, we believe that telling Albuquerque's stories can inspire other cities and towns to explore their own stories of place.

We hope *Never Say Good-Bye: The Albuquerque Rephotographic Survey Project* serves as a thoughtful guide to the ongoing redesign of the place we call home.

2017 The original articles in this collection first appeared in the pages of the *Albuquerque Tribune*. Founded in 1922 by Carlton Cole Magee as *Magee's Independent*, the *Tribune* closed shop on February 23, 2008. Newspapers across the world have struggled to survive the Internet Age: the *Tribune* did not.

Displacement of news to the Internet is an aspect of the emergence of the world-net-city—the popular culture, worldwide web, airport, and delivery service connected amalgam of global places. In this new world, we may shop cyber Monday, buy Christmas strawberries from the Southern Hemisphere, commute to L.A., be terrorized by events unfolding in real time in Beirut and Paris, distribute work flow across continents, be buffeted by worldwide economic forces, and ingest Hollywood *and* Bollywood stories, but we still put on our pants, go to school, meet friends for coffee, and otherwise live in the physical and social environment of Albuquerque. Thus our local stories, and indeed everyone's local stories, continue to matter.

The ability to engage and thrive in multiple "worlds"—to be a citizen of Albuquerque, an internationally best-selling author, a denizen of an online role-playing game, and a volunteer for a national nonprofit—to be, as the poet Walt Whitman would have it, "multitudinous," is an increasingly necessary skill. Creating robust venues for the news and stories of each of these places, which allow us to talk with and not past each other, is one of the central tasks of this era.

As was written in the news release announcing the demise of the *Albuquerque Tribune*, "Scripps acquired The Tribune in 1923 from its founder, Carlton Cole 'Carl' Magee. Borrowing a phrase from Dante, Magee had adopted the slogan 'Give Light and People Will Find Their Own Way.' After it was acquired, Scripps adopted Magee's slogan, for all of its newspapers" (Stautberg 2008). We still need to give light to the stories of place.

THE GENIUS OF ALBUQUERQUE

Anthony Anella

2017 In *The Geography of Genius* author Eric Weiner (2016) travels the world asking how and why creative genius flourishes in certain places at certain times in human history. In Athens, Greece, he asks: Why Socrates? In Hangzhou, China, he asks: Why Su Tungpo? In Florence, Italy, he asks: Why Leonardo da Vinci? In Vienna, Austria, he asks: Why Mozart? One of the patterns he discovers is that creative genius is most likely to flourish in places located at cultural crossroads: places where diverse ideas and ways of looking at the world intersect and mingle. He also discovers a correlation between enlightened leadership and the conditions that allow cultural diversity not just to coexist but to cross-pollinate. "Mozart was no freak of nature," Weiner writes, "he was part of a milieu, a musical ecosystem so rich and varied it practically guaranteed that, eventually, a genius like him would come along" (2016, 218).

Albuquerque is uniquely situated at a cultural crossroads in both space and time. The intersection of Fourth Street (the historic Camino Real connecting Hispano-America with Anglo-America) and Central Avenue (the historic Route 66 connecting the East and West Coasts and places between and beyond) is the epicenter of this spatial crossroads. It is also the epicenter of a temporal crossroads where the rich indigenous traditions of pre-Columbian America still breathe the same air as those traditions that invented the technology for splitting the atom and landing a man on the moon. What other city in America can boast of having the Indian Pueblo Cultural Center and the National Hispanic Cultural Center? These two cultural gems symbolize the rich history that makes Albuquerque such a wonderful and unique place to live. More than symbols of Albuquerque's history, they express the vital contemporary influence that Pueblo Indian and Hispanic cultures have in our city. The investments that went into building these two institutions testify to this fact. And what other city in America has both an Old Town organized

around a central plaza and Route 66, the most famously romanticized road in the country? These two artifacts of Albuquerque's history embody two very different interpretations of the world and how we are to dwell in it. If Old Town's plaza expresses a sense of community and social focus anchored by the Catholic Church and memories of Spain and Mexico, Route 66 expresses the exuberance of people from all ethnic and cultural backgrounds traveling to new places with the opportunity to write new histories, personal and otherwise.

Quirky Albuquerque juggles many different historical memories, some of them conflicting. The Atrisco Land Grant dates from a time when the nonindigenous rights to the land were governed first by Spain, followed by Mexico, and then, at the conclusion of the Mexican-American War, by the Treaty of Guadalupe Hidalgo. The treaty promised to respect the property rights of Mexican citizens living in the territory transferred to the United States, but these rights were often ignored by the United States. It does not take much to scratch the surface of our town for this history to come alive. The original design for the National Hispanic Cultural Center had to be changed to accommodate Mrs. Adela Martínez, the owner of a house located in the center of the proposed development, who stubbornly refused to sell her ancestral home. *Tierra o muerte*, land or death: there was no way the local Hispanic founders of the cultural center would dare condemn her property! The disrespect shown Mexican-Americans whose property rights the Treaty of Guadalupe Hidalgo was to have protected is too

fresh a memory. Although the house may be an odd sight within the new complex, it is still lived in by the descendants of the family matriarch who dug in her heels to successfully challenge the prevailing Anglo land-use laws. As a community, we owe her a debt of gratitude. The house enriches the National Hispanic Cultural Center by serving as a wonderful artifact of Albuquerque's living history.

Even Albuquerque's name is quirky. Named by the early Spanish colonists to honor the Duke of Alburquerque, somewhere along the way the first "r" was lost. According to acclaimed Albuquerque author Rudolfo Anaya (1992, 1), it happened around the time the railroad arrived in 1880: "Legend says the Anglo stationmaster couldn't pronounce the first 'r' in 'Albur' so he dropped it as he painted the station sign for the city."

Albuquerque is quirky precisely because of its diverse histories. In addition to the Pueblo Indian, Spanish, Mexican, and Anglo traditions that are so deeply rooted in Albuquerque's soil, there are estimated to be forty-seven different languages spoken in the International District (Martínez 2014). This is one of the reasons why the opportunities for historical and cultural cross-pollination are so rich in Albuquerque. Our city's greatest strength is the interaction of diverse ideas and ways of looking at the world that nurtures a culture of creativity and innovation. The genius of Albuquerque is its quirkiness.

What Albuquerque lacks is something to unify its quirkiness, something to knit the rich cultural diversity of our community together. It lacks a place to gather, a forum

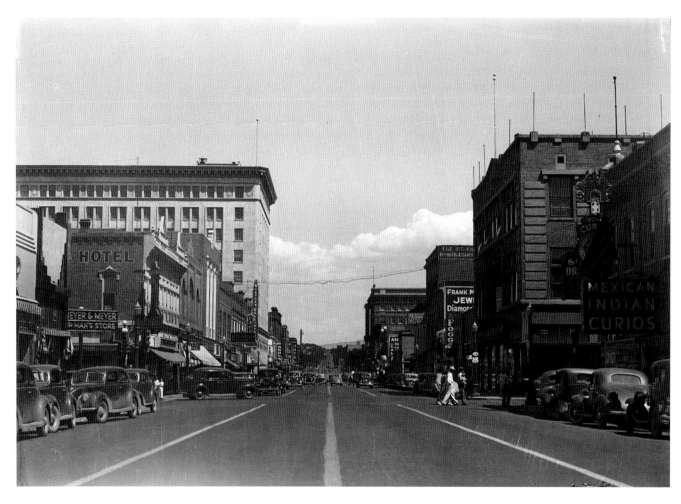

circa 1935. In this view looking east of Fourth Street and Central Avenue, the Meyer and Meyer Man's Store is on the northwest corner, the Selvia Hotel is on the northeast corner, the Rosenwald Brothers building is on the southeast corner, and a Mexican and Indian curio store is on the southwest corner. Courtesy of the Albuquerque Museum, Cobb Studio Photograph, PA 2014.1.272.

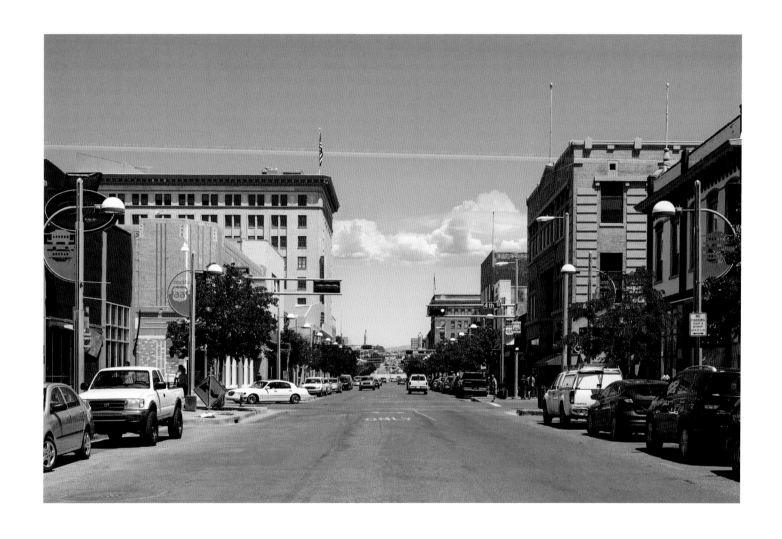

2017. The same view of Fourth Street and Central Avenue. Photograph by Robert Reck.

to promote the cross-pollination of ideas. Athens had the agora, which literally means "place where people gather." Albuquerque has the plaza in Old Town, but when the railroad came to town, the heart of the city moved east toward the railroad tracks. Albuquerque also has the so-called Civic Plaza, but one would never confuse its nearly shadeless concrete as a place to gather. In reality, Civic Plaza is the roof for an underground parking garage. Albuquerque needs to invent a local agora.

One of Albuquerque's advantages is its scale as a medium-sized city that makes it less prone to the enclaving that characterizes larger cities like Los Angeles or Chicago. But, like most cities that developed after the car, Albuquerque is characterized by a sprawl that makes it more difficult for people to gather and for ideas to mingle. This sprawl makes it physically impossible for Albuquerque to have a single agora. Albuquerque needs to invent a way for people to gather in the post-automobile age of the Internet: a place worthy of its blend of First Nations, Old World, and more recent immigrant roots.

What knits the United States together is the transportation and communication infrastructure that makes it possible for New York to talk to Detroit, Chicago to Houston, and Seattle to Albuquerque. The United States has the transcontinental railroad, the interstate highway system, airplanes, AT&T, Verizon, Sprint, and now Facebook and Google. To overcome the vast distances separating its citizens on the East and West Coasts, the United States created a virtual agora through the invention of transportation and communication efficiencies beyond anything Socrates could have imagined. What made the infrastructure that knits our country together possible was an enlightened form of government that promoted successful public-private partnerships. In the United States a mutually beneficial relationship exists between political democracy and economic democracy. Our political democracy would not have worked if Henry Ford did not build cars for the masses or if Alexander Graham Bell did not invent the telephone so that Jane Doe could talk with José Fulano. We live in a society that historically has acknowledged and rewarded the invention of better mousetraps without regard for the ethnicity of the mousetrap inventor. The genius of the United States is a meritocracy that attracts the most industrious and the brightest from all over the world to come together, united by a shared dream of realizing their fullest potential as individuals.

What knits Albuquerque together is less clear. The transportation efficiencies that make the continental United States viable as an economic unit don't work in cities like Albuquerque. One reason for this is our culturally ingrained preference for transportation independence. We like our private cars. They have become part of our individual identity. Only 1.55 passengers per vehicle was the national average in 2009 according to the US Department of Energy. Casual observation of vehicle occupancy rates in Albuquerque suggests it might be lower than that here. In terms of efficiency, it is one thing to consolidate cargo hauled by freight trains or sixteen-wheel trucks across a

continent and quite another to transport individual commuters in gas-guzzling automobiles across a city as spread out as Albuquerque. Although the internal combustion engine helps connect the United States as a whole, it also makes it difficult for cities like Albuquerque to function as places for people to gather. The car isolates us from each other in individual steel-and-glass cocoons. The car enables Albuquerque's sprawl, which exacerbates the isolation and further limits the opportunities for different ideas to mingle and cross-pollinate.

This dilemma is what makes it so critically important for Albuquerque to get its public transportation system right. The appropriate criterion for evaluating such a system is how well the system knits Albuquerque's diverse communities together and enables the mingling and cross-pollination of ideas. In short, how well the system connects the right dots.

The Albuquerque Rapid Transit (ART) system connects the wrong dots. Rather than reinforcing Albuquerque's strengths, the bus line runs down the middle of Central Avenue from Unser Boulevard in the west to Louisiana Boulevard in the east, and does nothing to nurture a culture of creativity and innovation. It does nothing to knit our community together. Instead, it perpetuates an old and tired pattern of development that rewards the land developer in the short term and penalizes the residents of Albuquerque in the long term. By beginning at Unser Boulevard it promotes the western sprawl that degrades Albuquerque's sense of place while at the same time it makes Albuquerque less competitive in the future due to higher—because more spread out—transportation and infrastructure costs. It is based on a one-size-fits-all design—executed by out-of-state engineering consultants—imposed on a roadway with varying right-of-way widths that make it ill-suited to accommodate two dedicated bus lanes running down the center median. The ART project is yet another example of our elected representatives adopting a bad design in exchange for a multimillion-dollar carrot that, in this case, the Federal Transit Administration dangled in front of them. Like so many Albuquerque politicians before them, Mayor Berry and all but two of the city councilors chose to harness Albuquerque's future to the federal yoke by succumbing to the temptation of federal money. Most unfortunate of all, the ART system does nothing to enhance Albuquerque's potential. It does nothing to knit the rich cultural diversity of our community together. By connecting the wrong dots, it makes it even more difficult to unify Albuquerque's quirkiness. It inhibits Albuquerque's genius from realizing its fullest potential.

The right dots to connect are those that play to Albuquerque's strengths: the places that give Albuquerque a unique sense of place, the places that make Albuquerque a cultural crossroads where different ethnic identities and ways of looking at the world can cross-pollinate. Imagine ART being redesigned so that it connects the Indian Pueblo Cultural Center with the National Hispanic Cultural Center (crossing the Civic Plaza to reconnect north Fourth Street with south Fourth Street and helping to bridge the

cultural schism that exists between Albuquerque's north and south valleys at the same time). Imagine ART being redesigned so that it connects the BioPark, Old Town (and Albuquerque's enlightened cluster of museums), New Town, the university, and beyond. It turns out the right dots to connect are also those that make Albuquerque an attractive place for out-of-town tourists. Imagine ART being redesigned so that it connects the airport, the National Hispanic Cultural Center, the Indian Pueblo Cultural Center, and the Railrunner, so that it is easier for out-of-state tourists who otherwise would bypass Albuquerque for Santa Fe to enjoy our city's cultural attractions while at the same time help support our local restaurants and hotels. Imagine ART being redesigned so that it serves to attract larger conventions to our city by making it easier for convention goers to visit our cultural treasures without having to rent a car. Imagine the Albuquerque Rapid Transit project as an engine of true economic development rather than a cynical and shortsighted ploy for real estate development. Imagine a great city that connects the right dots for Albuquerque to flourish.

LEARNING FROM *BREAKING BAD*
Mark C. Childs

2017 Set in and around Albuquerque, the multi-award–winning TV series *Breaking Bad* presents a conundrum to the city. On the one hand, this internationally famous show brings attention and tourism. On the other hand, identifying the city with the moral morass of drug trafficking is problematic. Addressing this potential problem in 2013, Albuquerque mayor Richard Berry noted the city's recent drop in serious crime and said, "I'm confident viewers have no difficulty distinguishing fiction from reality" (Gray Faust 2013).

Yet the play between fiction and place is what drives the tourism (otherwise why come here?), and the stories set in a place influence how we see a place. Paying attention to *Breaking Bad* makes us more likely to pay attention to suggestions and signs of the drug world. This is doubly true because the series actively incorporates the city in the story. As the *New York Times* reported, the show's creator Vince Gilligan "considers Albuquerque a character of *Breaking Bad*"

(Brennan 2013). Gilligan said Albuquerque has a "'stealth charm.' Once you get into the neighborhoods, you realize it possesses a great amount of culture and history and natural beauty surrounding it" (Brennan 2013).

The narrative landscape—the stories of a place—is a central factor in shaping the physical and social design of a city. For example, the lore of Route 66 continues to inspire changes in sign ordinances and historic preservation efforts. Tony Hillerman's detective novels prompt tourism in Navajo lands, and places associated with Billy the Kid's life of crime are well established throughout New Mexico. How then might we shape our urban responses to the challenging narrative of *Breaking Bad*?

I reviewed the series with the eye of an urban designer to note how Albuquerque itself was presented. I discovered three potentially useful perspectives—an appreciation for the landscape, an exploration of our neighborhoods' "stealth charm," and a dance with day-of-the-dead duende.

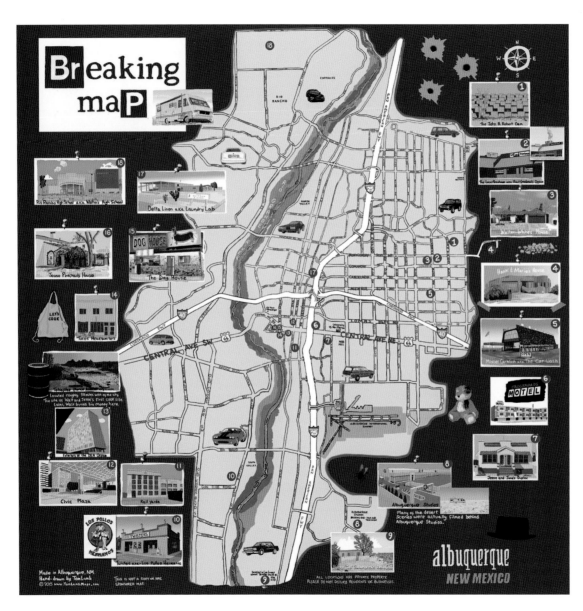

"Map of *Breaking Bad*."
Courtesy of Tom Lamb
(www.tomlambmaps.com).

The beauty of the Sandias and volcanoes is a well-established part of our narrative of place and has been part of urban planning for some time. Views of the Sandias and the volcanoes with their petroglyphs add to home prices. Albuquerque's 1980s comprehensive plan helped keep the city from spreading up into the Sandias and, for a time, limited westward sprawl. Our Open Space Division has also been highly successful in helping preserve this central component of who we are. *Breaking Bad* uses the mountains as a place-setting backdrop. However, many of *Breaking Bad*'s scenes are set in our open Chihuahuan desert, away from settlement, and here the cinematographers find a stark beauty. They compose mythic settings—the line of a dusty road under a jet trail–filled sky, the light changing over the prairie—whose enduring beauty contrasts with the story's violence. When I have European visitors, the view *west* from the volcanoes out into this vastness is what most astounds them. We would be wise to preserve this landscape.

The "stealth charm" of our neighborhoods and mid-century kitsch commercial buildings is well played in the series. The Dog House Drive-In and Central Avenue in Nob Hill, for example, are used as transitions. The old Octopus car wash and the Crossroads Motel play critical roles as distinctive locales. Jesse and Jane's duplex itself almost tells the story of their relationship. The lesson is that there is a distinctive depth—a unique narrative of place—in our mid-twentieth-century landscape of homes and businesses. Let's not be in a rush to discard it.

The poet Federico Garcia Lorca described duende as an irrational, earthy struggle with death and a touch of the diabolical. This spirit in flamenco and other Spanish arts certainly inhabits *Breaking Bad*. Not only does the storyline dance with duende but the cinematographers found it in difficult places. For example, one early episode shows Jesse amid a field of broken concrete near the railyards; the setting perfectly captures the mood and is a graphically stunning artwork. But for me, the genius of the show is epitomized by the Whites' pool, which is presented as both an ordinary, everyday place and an extraordinary magical realm. This ability to "find" the sublime is, I believe, both prevalent in Albuquerque and a key to improving our city. Rather than looking elsewhere for the zest of the month, we need to do the harder work of transforming difficult landscapes into profound places.

How might these ways of seeing Albuquerque inform how we build Albuquerque?

We should continue our efforts to preserve our landscapes. The subtle but profound beauty of the open desert has not been as easy to preserve as the mountains. Yet the near adjacency of a metropolitan downtown to the raw desert is a rare and valuable thing. We should avoid the endless sprawl of our cousin cities of Phoenix, Las Vegas, or Colorado Springs.

Building on the "stealth charm" of our neighborhoods and iconic buildings is not only a matter of preservation. It also suggests that we find ways to reuse buildings that have outlived their original purpose, infill our older neighborhoods with buildings and landscapes that respond to

and perhaps play with the neighborhood's charms, and invest in repairing and upgrading the neighborhoods' aging infrastructure. This may require that we rebalance impact fees, regulations, and other factors that favor construction on the edges of the city.

Struggling with duende is perhaps the most difficult but critical lesson to apply to urban design. An artwork by Guerrilla Graphix, a local graphic design company, suggests an approach. It shows Walter White in his trademark hat as a day-of-the-dead sugar skull. This wryly plays with *Breaking Bad* as the latest incarnation of an ancient narrative. Likewise, when we think of Central Avenue as the mother road with all its difficult tales of travel, the railyards as a relic of a nation-spanning industry waiting for its next inhabitants, abandoned Route 66 signs as cryptic messages from the past and canvases for our future, a disused mental hospital as an upscale hotel, then perhaps we are tapping into myth, struggling with dark duende but keeping a sense of play. To borrow from another poet, Ellen Bryant Voight, we must acknowledge our struggle with the forces of loss but celebrate our accomplishments with the forces of plenty.

LEARNING FROM MARTÍNEZTOWN
Anthony Anella

2017 In life either we insist on writing our own story or we allow others to write our story for us. The story of Martíneztown is of a community stubbornly and persistently insisting on writing its own story, of a community reaffirming its history and its geography as a place that matters in the face of seemingly overwhelming social, financial, and bureaucratic odds. The story of Martíneztown is also the story of a community finding strength through unity.

The story begins with rebellion. Social and political unrest characterized the United States in the decade roughly defined by the assassination of President Kennedy in 1963 and the resignation of President Nixon in 1974. It was a time when the unprecedented economic prosperity following the Second World War led to a perception of the national economy as forever expanding. This led to an unfortunate period of government overreach, both internationally and domestically. The same hubris that led our political leaders to fight a war halfway around the world in Vietnam—without regard for the powerful motivation of the people of that country to protect their homeland—also led our political leaders to believe our government could win the war on poverty with one-size-fits-all programs without regard for the power of local history.

First settled in the 1820s, Martíneztown is located at the crossroads of the historic Camino Real, which ran north-south, connecting Mexico City to Santa Fe, and two branches of the Tijeras Canyon Trail, which ran east-west, connecting the irrigated lands of the valley with the firewood and wild game in the Sandia and Manzano Mountains. The Camino Real crossed the Rio Grande at what is today Bridge Street near the National Hispanic Cultural Center. One spur went directly to Old Town, but the main road to Santa Fe headed north on what is today Fourth Street, and then turned east on what is today Tijeras Avenue to get to the higher ground above the river's floodplain,

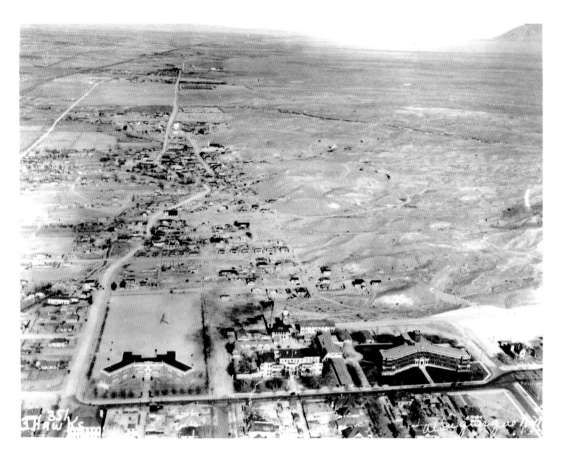

1932. This aerial photograph, looking north, is of Martíneztown. At the lower left corner is the intersection of Edith Boulevard—El Camino Real de Tierra Adentro—and Grand Boulevard (now Dr. Martin Luther King Jr. Boulevard). Edith Boulevard is the dirt road heading north along the foot of the east mesa. The dark ribbon of water to the west of Edith is the Acequia Madre de Barela. Longfellow Elementary School is at the northeast corner of Edith and Dr. Martin Luther King Jr. Boulevard. Manuel's Food Market is near the northwest corner of the school's playground. Three Hawks photograph courtesy of the Albuquerque Museum, Albuquerque Museum Collection, 1978.141.013.

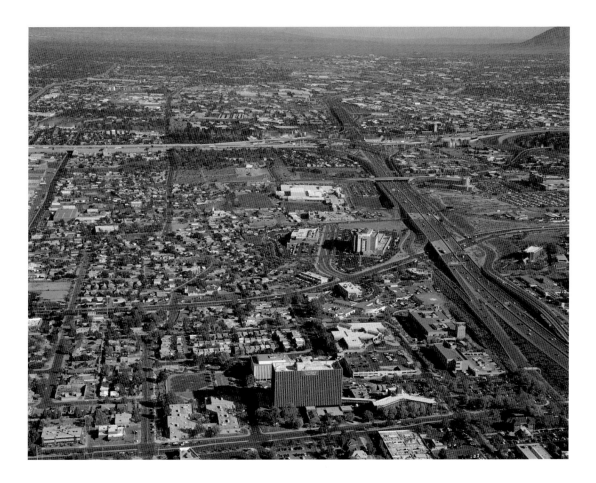

2017. In this similar view of Martíneztown, the intersection of Edith Boulevard and Dr. Martin Luther King Jr. Boulevard can be seen near the bottom of the photograph halfway between the left edge and the center of the photograph. (The view differs from the historic photograph because it is taken from a higher elevation with a different camera and lens.) Longfellow Elementary School still exists at its original location at the northeast corner of Edith and Dr. Martin Luther King Jr. Boulevard—albeit in a new building—just to the west of the Lovelace Medical Center (formerly St. Joseph's hospital, which was built by the Sisters of Charity). Manuel's Food Market can still be seen near the northwest corner of the school's playground on Roma. El Camino Real de Tierra Adentro National Historic Trail can be seen on the east side of Edith between Dr. Martin Luther King Jr. Boulevard and Roma. The Acequia Madre de Barela no longer exists. Photograph by EaglesEyePhoto.com.

and then north again along what today is Edith Boulevard. Martíneztown is also located along the ancient Acequia Madre de Barela, a mother ditch that diverted water from the Rio Grande near Sandia Pueblo, followed the contours of the land at the foot of the east mesa along what today is Edith Boulevard, crossed Lomas Boulevard near the heart of Martíneztown, and then turned southwest back toward the river at what today is the Public Service Company of New Mexico substation on Marquette. Trade along the Camino Real and water from the *acequia madre* created a strategic location for two permanent settlements. One was south of Lomas near what is today Manuel's Food Market on Edith, which was established around 1810. Local Hispanic residents know this area as South Martíneztown. The other was north of Lomas, which was established around 1850 by don Manuel Martín who brought his family out of Old Town when he converted to Protestantism. This area is known as Santa Bárbara-Martíneztown.

After the arrival of the railroad in 1880, the story of Martíneztown is both tortured and inspirational. In 1885 the incorporation of Albuquerque excluded Martíneztown even though it was one of the oldest and most historic parts of town. In 1955, when Albuquerque adopted zoning, the area of Martíneztown south of Lomas Boulevard was zoned "Public and Institutional" and the area north of Lomas was zoned "Commercial and Manufacturing" even though both areas were mostly residential. This zoning had a redlining effect on the community: there was no reason for the city to invest in infrastructure to support residential needs in Martíneztown, and there was no reason for banks to lend money for residential purposes. As public policy, the change in zoning had the effect of depriving Martíneztown of its residential future. Conveniently (for the city planners), the neighborhood seemed destined to become Albuquerque's new civic municipal complex. However, the voters failed to approve the bonds necessary to make this happen. This created a zoning vacuum that planners in the 1960s attempted to fill with a new zoning designation: "Hospital and Educational."

The near fatal blow to the neighborhood came in the 1970s when the federal urban renewal program decided to designate Martíneztown as "blighted," "slum," "substandard," and "scheduled for condemnation"—all the terms needed to legally justify eminent domain. This designation dovetailed conveniently with the city's new plans to create a medical and educational center in the part of Martíneztown south of Lomas. The designation seemed reasonable to the planners. Martíneztown had no paved roads, no sewer, and no flood control. The Anglo residents of Albuquerque at the time referred to the area as "Dogtown" (an anglicized bastardization of "Adobetown"). But what this designation ignored was Martíneztown's cultural resilience. It is one thing for government planners to draw arbitrary and capricious lines on maps and quite another to understand the historic realities on the ground. The citizens of south Martíneztown refused the federal designation. They refused to let a remote federal bureaucracy working in concert with an equally detached municipal bureaucracy pave over their history.

When the Sisters of Charity needed to build a hospital in the 1960s, they entered into an agreement with the Albuquerque Public Schools (APS) and the City of Albuquerque as a third-party beneficiary to the agreement. APS needed land for building a replacement for the old Albuquerque High School. The city agreed to provide a building site in south Martíneztown for the new high school if APS would give up the Longfellow Elementary School for a parking lot for the hospital being proposed by the Sisters of Charity. In an effort to finalize the agreement, the city used the vehicle of urban renewal to condemn the historic neighborhood. In the early 1970s urban renewal relocation officers started knocking on doors in south Martíneztown, telling the residents that their homes were being condemned. This didn't go over well. The residents responded by organizing themselves into the Citizens Information Committee of Martíneztown (CICM) and proceeded to fight condemnation by developing their own plans for what they wanted Martíneztown to become.

It is noteworthy that the word "information" is featured prominently in the name of the Citizens Information Committee of Martíneztown. The original board members of the CICM (Frank Martínez, Richard Martínez, Maria Martínez, Joe Estrada, and Sister Marcella Campos) understood that the dissemination of *accurate* information was key to promoting resident participation. They understood that countering the voluminous misinformation disseminated by city government and the local newspapers was essential for the citizens of Martíneztown to be able to make informed decisions about whether or not to accept urban renewal. The CICM made sure the residents had accurate information about planning policies, planning methods, and real estate law. For example, the CICM advised the residents to get multiple appraisals of their property to ensure a fair evaluation and to research the cost of moving to another neighborhood before entering into any agreements with the urban renewal officers. In addition to using words like *"En Unidad, Hay Poder"* (In Unity, There Is Strength), the CICM could have also used the rallying cry *"En Información, Hay Poder"* (In Knowledge, There Is Power).

The CICM board understood they were campaigning for a vision of Albuquerque's future that conflicted with the "progress" envisioned by Albuquerque's government and business leaders. Further, they understood that the Anglo middle-class orientation toward growth threatened the social fabric and cultural integrity of the Martíneztown neighborhood. In response, the CICM insisted on a vision for Martíneztown's future that was rooted in honoring Martíneztown's rich history and that reflected the ethnic identity of the people of Martíneztown. The CICM board organized a campaign based on activating kinship networks and neighborhood bonds that already existed within Martíneztown. It was a grassroots campaign that promoted cultural awareness while at the same time working within the established political system. The genius of the CICM campaign was a fundamental respect for citizen participation in the democratic process combined with a

stubborn commitment to the democratic ideal that elected representatives should answer to their constituents. Vanessa Macías (2007, 85) describes an incident between US senator Clinton P. Anderson and CICM founding board member Frank Martínez that illustrates this genius:

In June 1971, Frank Martinez asked Senator Anderson to assist with CICM's administrative complaint against the city. Submitted in October 1971, the administrative complaint addressed inequities in urban renewal policy as applied to south Martíneztown. Based on this evidence the formal complaint asked the Department of Housing and Urban Development (HUD) to reject plans for the neighborhood. Anderson responded that he could do nothing because the matter was "now before the courts." In fact, HUD was still reviewing the administrative complaint. Correcting the Senator about its status, Martínez stated that residents believed "elected representatives should keep up to date about issues concerning them." To his credit, Anderson apologized for the misunderstanding and promised to intercede on south Martíneztown's behalf.

Frank Martínez understood that to be most effective in countering urban renewal's plans for Martíneztown, alternative plans were needed. He enlisted the support of the Design and Planning Assistance Center (DPAC) at the University of New Mexico School of Architecture and Planning directed by professors Richard Nordhaus and John Borrego to help the residents visualize what their own self-determined rhetoric had the potential to look like for Martíneztown's redevelopment. For over a year and a half, DPAC students and professors helped educate in Spanish and English—the residents of Martíneztown about the process to create their own vision and make informed decisions about their future. To support the organic, community-based vision that resulted from these efforts, Martínez also enlisted the support of the Albuquerque Legal Aid Society, the Community Relations Service of the Department of Justice, the Earl Warren Legal Institute of Berkeley, and the Catholic Church's Campaign for Human Development. He also enlisted the support of minority organizations such as the League of United Latin American Citizens, the Mexican American Legal Defense and Educational Fund, and the GI Forum.

At the same time the CICM was organizing this grassroots education and visioning campaign, the Albuquerque Urban Coalition was formed. A series of riots in the early 1970s caused Albuquerque's business leaders to worry about the economic impact of social unrest. To counter social unrest, the business leaders sponsored the Albuquerque Urban Coalition, which, like the National Urban Coalition, was seen as an antidote to the government overreach of urban renewal. What made the Albuquerque Urban Coalition so effective was the remarkable young activist and citizen named Frank Martínez—the same Frank Martínez who had challenged Senator Anderson

to act on his community's behalf—who served as its first executive director.

Politically astute and motivated by a profound sense of caring for his community, Frank Martínez cultivated a direct connection with the business leaders of the Albuquerque Urban Coalition. He forged a powerful alliance between business leaders and Albuquerque's civic, religious, and minority leaders to reaffirm the importance of honoring Martíneztown's local history and local sense of place. The group consisted of enlightened citizens such as Jack Rust (Rust Caterpillar), General Emmanuel Schifani (Springer Corporation), Mannie Blaugrund (American Furniture), George Schreiber (PNM), Jim Killorin (Mountain Bell), Hickam Galles (Galles Car Dealerships), Cale Carson Sr. (First National Bank), Ray Powell Sr. (Sandia National Laboratories), General Francis Nye (Kirtland Air Force Base), Ted Martínez (Albuquerque Public Schools board), and Archbishop James Peter Davis (Archdiocese of Santa Fe).

Martínez persuaded the Albuquerque Urban Coalition to adopt as its first project the goal of settling the dispute caused by finding a new site for Albuquerque High School. To achieve this goal, Emmanuel Schifani offered to sell land owned by the Springer Corporation located north of Mountain Road to APS as a site for the new school, and Ted Martínez advocated internally for APS not to condemn the residences of Martíneztown for a new high school to avoid damaging the community. APS pulled out of the agreement with the city and the Sisters of Charity.

Martíneztown was spared the disrespect of condemnation, Longfellow Elementary School did not become a hospital parking lot, and Albuquerque preserved an important part of its history and civic pride.

On September 27, 2016, at a ceremony in Martíneztown, the National Park Service dedicated El Camino Real de Tierra Adentro as a National Historic Trail. Representatives from the Spanish and Mexican governments attended. The ceremony took place at Martíneztown Park, the culmination of a recently completed linear park that begins at Longfellow Elementary School (the same school saved from becoming a hospital parking lot and one of the first elementary schools in Albuquerque to become a magnet for bilingual education) and runs north along Edith Boulevard to Roma Avenue, just south of Lomas Boulevard. Conceptually, the park condenses the experience of traveling the 1,600-mile Camino Real from Mexico City to Santa Fe. As you walk from south to north along this linear park, markers embossed in the sidewalk indicate the distance traveled from Mexico City, and the landscaping reflects the corresponding change in vegetation of the three different ecosystems the Camino Real traverses. Ceramic tiles depict the animals and landmarks along the Camino Real, and plaques narrate the experience with excerpts from the historic journals of those who traveled it. A special panel in Martíneztown Park celebrates the community's history. And in a rare but far from accidental instance of poetic justice, the symbolic trail culminates at a sculpture by the distinguished artist Luis Jiménez that depicts the Mexican

legend of immortal love between the warrior Popocatépetl and Iztaccíhuatl, who died of grief after being falsely told her lover had been killed in battle.

The story of Martíneztown is the inspiring story of citizen leadership and of what is possible when individual egos are set aside for the benefit of the larger community: the story of a neighborhood finding strength through unity. Behind the scenes of the ceremony dedicating El Camino Real de Tierra Adentro was a citizen of Albuquerque who worked for more than forty-five years to protect the cultural and historical integrity of Martíneztown. When asked what sustained his efforts, Frank Martínez, the remarkable citizen activist who helped found the Citizens Information Committee of Martíneztown and who served as the first executive director of the Albuquerque Urban Coalition, responded simply, "Because I was born and have lived my life here" (pers. comm.).

Martíneztown is unique in the urban history of the United States because it is one of the only neighborhoods in the country to successfully fight condemnation and also reverse its designation from "blighted and condemned"

to that of "redevelopment." Martíneztown has also had to overcome being declared a federal disaster area due to the collapse of a sewer lateral that runs under the neighborhood and is currently having to address the Fruit Avenue Plume Superfund site within its boundaries. What makes this story so inspirational is how Martíneztown has overcome these adversities and succeeded in asserting its own plan to revitalize itself based on a reaffirmation of its own history.

By insisting that future development honor its history, Martíneztown provides an inspiring example: the collective wisdom of an engaged—because accurately informed—citizenry is more valuable to the creation of quality living environments than the sterile planning of a detached bureaucracy. To quote Frank Martínez (pers. comm.), the example of Martíneztown is that of "a seed becoming the flower of a new botany for development in Albuquerque." The hopeful lesson to be learned from Martíneztown is how a community—through perseverance and love—can prevail against seemingly overwhelming social, financial, and bureaucratic odds to assert itself by insisting on telling its own story.

THE ORPHAN SIGNS
Mark C. Childs

2017 One of the key characteristics of Route 66 was its creative ferment. Route 66 helped develop the motel, alliances of motels, and some of the first motel and fast food chains. Iceberg-shaped gas stations, fantasias of miniature golf, and many other creatures of kitsch arose along the edge of the Mother Road. And, perhaps most iconically, Route 66 sprouted a spectacular crop of roadside neon signs.

In 1912 the first neon advertising sign was installed on a barbershop in Paris. Neon signs are first recorded in the United States in 1923 at a Los Angeles car dealership (Ribbat 2013, 35). The neon sign installed for the 1927 Firestone building on Central Avenue near downtown may have been Albuquerque's first neon sign.

Nationally, the great era of neon bloomed in the late 1920s and 1930s, flickered during World War II, and had a second flowering through the 1960s. The 1960s and early 1970s were the heyday of Route 66 signage in Albuquerque, as famously illustrated by the Ernest Haas photograph of Central Avenue, *Route 66, Albuquerque, New Mexico* (1969). It shows the street east of Carlisle with a wild thicket of signs lining both curbs. The Terrace Drive-In Theater's flamenco dancer whose skirts swayed with neon, the Paris Shoes neon script, the Public Service Company's Reddy Kilowatt, and the KiMo's sign were perhaps Albuquerque's most iconic signs. But I know others would argue for the little devil on Eddie's Inferno, the Bimbo's sign, or other favorites.

The glory days of neon faded in the late 1970s. As Ellen Babcock and I wrote in our book, *The Zeon Files*, "By the late 1970s the cheaper, more durable, and easily changed backlit plastic signs crowded out neon. In Albuquerque this change was abetted by new sign ordinances that limited height, size, shape, and motion. A 1976 Albuquerque ordinance, for instance, caused the soaring sail-shaped sign of the Trade Winds Motel to be lopped to half-mast, and most new sign design in the Central Avenue corridor

2009. The unused El Sarape sign. Photograph courtesy of Ellen Babcock and Friends of the Orphan Signs.

2012. *Revivir*. Under the direction of lead artist Ellen Babcock, Friends of the Orphan Signs (FOS) members Aline Hunziker, Bethany Delahunt, and Lindsey Fromm worked intensively with Highland High School students from January to June 2011 to develop designs for a sign at 4119 Central Avenue. Forming an afterschool art club, the FOS team introduced digital graphic design skills, critical thinking exercises, and exploratory field trips to the teens as part of a collaborative design development focused on this particular orphan sign. Funding by the Albuquerque Arts Board, support from property owner Matthew Terry, and expert production by Sign Art Co. of New Mexico came together to produce the backlit, neon-lined sign that showcases the artwork of teens Hilary Weir, Ellie Martin, Gabe Thompson, and Desiree Marmon. Photograph courtesy of Ellen Babcock and Friends of the Orphan Signs.

135

to be limited to rectangular shape" (Childs and Babcock 2016, 8).

These ordinances "grandfathered" many existing signs, allowing certain signs such as the Zia Motor Lodge sign to stay. Because these structures preserved the right to have a large, distinctive sign that would otherwise not be allowed, the property owners preserved them even as buildings sat unused or were torn down. Thus, at the turn of the twenty-first century, Central Avenue sported a collection of disused, pigeon-filled, unusually shaped frames of signs.

Adaptive Reuse

As defined by the award-winning architectural firm Perkins + Will (2017), "Adaptive reuse entails reinventing existing buildings for new uses. We begin by identifying the defining characteristics of a given structure and then imagining how those features might creatively serve new purposes. We seek the best ways to respect a building's original design when making alterations and additions. Our work honors a site's past while supporting the present and innovating for the future." This is an ancient practice. For example, the Temple of Concordia in Akragas, Italy, was constructed by the Greeks around 440 BCE. At the end of the sixth century under Pope Gregory, the space between its columns was enclosed and archways were created in the walls, and it was reused as a Roman Catholic church.

The Albuquerque nonprofit Friends of the Orphan Signs (FOS) brought this practice to the unused grandfathered signs to create public art. The Royal Inn was built in the early 1970s at 4119 Central Avenue NE (see photo on page 134), another in a long tradition of Route 66 motels in the Nob Hill section of Central. By the twenty-first century the motel had been demolished, leaving only two unused signs. In 2011 this became one of FOS's first projects (see photo on page 135). Since then FOS has developed a handful of similar projects, and the City of Albuquerque Public Art program sponsored a project to reuse the Sundowner Motel sign. Albuquerque Public Art Urban Enhancement Program manager Sherri Brueggemann believes the adaptive reuse of orphan signs and the creation of new art riffs on Route 66 signage can be "a stable, ongoing current of who we are as a city" (Childs and Babcock 2016, 103).

These projects continue the creative ferment that was central to Central Avenue's life as part of Route 66, and they point to an opportunity. Rather than accepting the soul-numbing forms of "standard" parking lots, cell phone towers, power lines, and substations, could we learn from Route 66 and finds the ways and means to apply a bit of creativity and joy to the design of everyday and otherwise utilitarian components of our cities?

WALKING THE WALK
Mark C. Childs

2017 Before dawn hundreds of people—families, tourists, teenagers—with their flashlights and gear walk and ride their bicycles along the path, chatting, laughing, listening to music. Some bikes have elaborate spoke lights and decorations. Opened in 2008, the extension of the North Diversion Canal (NDC) trail to the Balloon Fiesta Park provides a large number of people an alternative entry into the Albuquerque International Balloon Fiesta. This trail reduces the fiesta's traffic snarl and creates an informal predawn parade. The NDC trail also serves bicyclists and walkers throughout the year.

Trails, sidewalks, crosswalks, and other pedestrian facilities are often considered, well, pedestrian—mundane, dull. To build careers, politicians often want to build freeway interchanges, river bridges, airport improvements, or spaceports. Yet a robust pedestrian network can be a low-cost means to improve traffic, health, the economy, and the environment. Transit systems rely on pedestrian networks, and convivial sidewalks are likely key to neighborliness and crime prevention. History also suggests that highly creative cities are also bustlingly pedestrian environments.

Sidewalks have been a normal part of urban street design. Historically, paving sidewalks frequently preceded paving the center of the street. However, as suburbs arose and particularly with the development of automobile-dependent suburbs, sidewalks were often considered an unnecessary frill, and municipalities did not require developers to provide a robust system. This has left many parts of Albuquerque with poor or absent paths for children to safely walk to school, for evening strolls around the neighborhood, or for a workday walk to the bus stop.

Albuquerque has incrementally begun to pay more attention to pedestrian facilities, and there is much more that could be done.

One of the first programs to systematically improve and provide sidewalks where the initial development had

1938. WPA stamp in Nob Hill sidewalk. These reminders of the Works Progress Administration are slowly disappearing as sidewalks are repaired and replaced. Photograph by Mark C. Childs ca. 1998.

2015. *Water Table* by a University of New Mexico Landscape Architecture class led by associate professor Katya Crawford (lead designers: Beverly Fisher, Wendi Fox, Michael Pace, and Madeleine Aguilar). A temporary "parquito" installed for Parking Day and the 516 Arts Block Party, part of their fall 2015 exhibition, *HABITAT: Exploring Climate Change through the Arts*. Sponsors: NMASLA, Plant World, RAKS Lumber. Photograph courtesy of Katya Crawford.

failed to do so was the federal Works Progress Administration (WPA). In 1935 Congress created the WPA, the largest of the New Deal agencies, and it operated for eight years. In addition to its celebrated arts projects, public buildings, and parks, the WPA also worked on infrastructure such as 1.1 million culverts, 16,000 miles of water lines, 24,000 miles of sewers, and 31,000 miles of new and improved sidewalks (US Federal Works Agency 1947). Albuquerque's first-ring neighborhoods like Nob Hill gained new sidewalks from this program, and WPA stamps can be found throughout the core of the city (see photo on page 138). Twenty-first-century efforts include the Downtown Walkability Study, Urban ABQ's "parquitos," and the City of Albuquerque–Albuquerque Metropolitan Arroyo Flood Control Authority (AMAFCA) trails.

Downtown Walkability Study

In March 2015 the city adopted the recommendations of the Downtown Walkability Study (DWS). Sponsored by Councilor Isaac Benton, the DWS made recommendations about "what changes can be made, in the least time, and for the least cost, that will have the largest measurable impact on the amount of walking and biking downtown" (Speck 2014, 4). The recommendations included increasing on-street parking to provide a buffer between pedestrians and moving vehicles, replacing traffic lights with stop signs, creating two-way rather than one-way streets,

splitting Civic Plaza into smaller parts, adding parks and green spaces downtown, and increasing downtown housing.

The study also outlined the economic, epidemiological, and environmental arguments for providing a good walking network. The economic benefits include real estate values, reduced automobile costs, and attracting millennials. Exercise, including everyday walking, can reduce obesity and its related diseases, and reduced driving reduces automobile crashes. The environmental benefits come primarily from reduced driving, and multiple studies show this to be one of the most important factors in reducing household energy use.

Parquitos

In 2010 San Francisco created five small public spaces by building temporary sidewalk extensions with seating, art, and other amenities atop street-side parking spaces. This pilot program launched the "parklet" movement. San Francisco has continued with this program and in 2015 the Pavement to Parks Program issued the second version of its Parklet Manual (which can be downloaded from http://pavementtoparks.org/parklets/#parklet-manual) partially to assist other cities wishing to implement such a program. Urban ABQ, a group advocating for a denser, walkable, and bikeable city, followed this lead and promoted a local variation on the parklet movement.

In the fall of 2013 a UNM School of Architecture and Planning (2013) studio also developed designs for "parquitos" across downtown. In December 2014 Albuquerque's first parquito was built in front of the Zendo Art and Coffee Bar at 413 Second Street SW. Unfortunately, in January 2016 a driver smashed into the structure and destroyed it. Hopefully this is not the last we will see of these delightful structures.

City-AMAFCA Trails

The trails along the arroyos and diversion canals, such as the path to the Balloon Fiesta Park, are on property controlled by the AMAFCA and licensed to the City of Albuquerque. The city pays for the design and construction of the trails. The original license agreement between the city and AMAFCA was signed July 13, 1994. The first amendment to the license, which included the NDC Trail to Balloon Fiesta Park as well as others, was signed May 13, 2003.

AMAFCA was not created to provide trails, but this innovative agreement has allowed the development of an extensive off-road network. Over the years there has been discussion of developing a similar agreement with the Middle Rio Grande Conservancy District to manage trails along the acequias.

The success of this system shows that bicycling and pedestrian facilities are valuable throughout the city, and current joint-use projects such as those for the Alameda Drain Trail and the trail to the Valle de Oro National Wildlife Refuge are good additions to the network.

More

Much more could be done to provide not only a good travel network but also great public places. The network could be improved by requiring "live-end" streets in subdivisions; developing robust programs to complete, improve, and repair sidewalks within a half mile of bus stops; "zoning" the sidewalks for multiple use; and establishing a city program for public spaces.

"Live-end" streets are dead ends for automobiles that have pedestrian/bike paths that link to other paths or streets. This occurs informally in the valley where streets end at acequias. However, because live ends have not been required in subdivisions, there are multiple neighborhoods that abut a trail, yet residents cannot readily get to the trail. In many cases these right-of-way extensions would also allow more efficient utility networks.

Bus stops need both good bus service and a good network of sidewalks and bike facilities. Too often cities focus on the bus part of the equation and don't spend funds to make certain that people can easily, safely, and enjoyably get to and from the bus stop. As we spend more on transit facilities, we should do the detailed work to improve both parts of the system.

Portland, Oregon, and other cities have adopted a system of "zoning" sidewalks to provide adequate areas for

walking, street utilities, furniture, and sidewalk sales and cafés. Formally adopting such a system makes it clear that a power pole cannot be placed in the middle of the walking area and that a zone should be available for street lights, newspaper boxes, power poles, bus shelters, and such. In places perhaps street vendors, informal stages for street performers, artwork, and other amenities could also be provided.

Finally, sidewalks and trails are not just travel lanes for bikes and pedestrians. They are places to hang out, meet people, watch street musicians, sip a coffee, and enjoy public life. Provision of places for people to gather and socialize in public is an ancient principle of city design. For example, the Laws of the Indies, the Spanish Crown's rules for settling the Americas, required not only the creation of plazas and pasture commons, but "around the plaza as well as along the four principal streets which begin there, there shall be portals, for these are of considerable convenience to the merchants who generally gather there" (Crouch, Garr, and Mundigo 1982, 14).

A great city has vibrant sidewalks.

AFTERWORD
Mark C. Childs

2017

The 1946 photograph on page 2 shows the KiMo Theatre where, as the marquee shows, the Errol Flynn movie *Never Say Goodbye* was playing. This is where we found the title for the original series of essays, and this reuse reflects a central tenet of this book.

Preserving history is critical to culture. As Winston Churchill said, "A nation that forgets its past has no future." However, building on, reusing, and riffing on history is also an essential feature of culture. Shakespeare, for example, rewrote *Hamlet* from an ancient tale that was first put in print in the twelfth century by Saxo Grammaticus in his *Historiae danicae* (Shakespeare 1998). Likewise, Tom Stoppard's play *Rosencrantz and Guildenstern Are Dead* (1966) takes place off the stage of *Hamlet*. This imaginative reuse of previous work provides *both* continuity and change, and, at its best, helps us see the past anew, enriches the current work, and holds out the possibility of new imaginings in the future.

Thus, we hope that this revised and updated book has fruitfully examined ways that Albuquerque has built on and revised its past. The rephotography of the original essays shows that some of these changes have been respectful and imaginative elaborations of querencia (a place from which one's strength of character is drawn, a place where one feels at home, that Tony wrote about in the preface). Others have disregarded the past. We can learn from both our successes and failures.

After almost two decades, reexamining these essays based on urban rephotography, I believe that rephotography should be a widely used tool of urban planners, landscape architects, architects, and others who shape our built environment. Strong design starts with deep analysis of the contexts. Too often site analysis consists solely of

understanding the engineering aspects of the property on which a project will be built. Such a site analysis typically includes topography and hydrology, solar exposure, utility location, descriptions of nuisances such as noise, and adjacent automobile traffic counts.

Rephotography can help with these technical analyses. For example, topographic changes may be revealed in historic images, showing areas that were once basements and are now loose fill. But more importantly, rephotography adds history and story to the analysis. Overly technical analysis misses the dreams invested in previous buildings, the adaptions and inventions added during the years, and the stories that places evoke.

In my work with Ellen Babcock uncovering the history of Route 66 commercial signage, we discovered that these very commercial built forms served both as public landmarks and talismans of individual histories (Childs and Babcock 2016). Upon seeing drawings of long-gone signs, many people spontaneously told us personal stories such as "an older woman tried to seduce me when I worked at that coffee shop," or "I liked to imagine that Frank Sinatra hung out in Eddie's Inferno, and I invented entire stories of what happened there." Signs and buildings anchor stories of place, and rephotography can be a tool to plumb those stories.

Seeing the history of a site and contemplating the forces that changed a place and the characteristics that endure should help us look to the future more clearly and continue to build a great place.

NOTES ON REPHOTOGRAPHY

1. *Look Back to Look Forward*

 History can be fascinating for its own sake. However, the purpose of an urban rephotographic survey is to give perspective on current and future decisions. In this sense, the project can be thought of not simply as "then and now" but as "then and now what?" To help select the sites for our rephotography, we reviewed current newspaper stories and academic articles on architecture and urban design to develop a list of issues facing Albuquerque.

2. *The Good, the Bad, and the Ugly*

 Resist the temptation to promote the past as a golden age (or as naïve, simple, or otherwise mono-dimensional). Every city has lost some treasures, saved others, and improved on various poor conditions of the past.

3. *Variety of Times*

 The lessons embodied in the history of places are often dismissed as simply belonging to a "different time." If you include changes that have occurred in the recent past as part of the survey, you can help illuminate the continuity of change.

4. *Stories Evolve*

 We selected each historic photograph with a particular purpose in mind. However, the process of rephotographing the site and researching its history significantly reshaped the story. We learned from the work and that learning improved our carefully planned initial agenda.

5. *Engage Community Participation and Support*

 The first publication of the original articles was in

an evening newspaper. This was once a good means to engender a larger community conversation. Without this widely shared venue, multiple venues would need to be used to reach a spectrum of readers.

To help defray the cost of producing the photographs, we asked members of the community to sponsor individual articles. Soliciting these sponsorships became an important part of the process. Preservation of our cultural heritage along with conservation of our natural resources can only be achieved if people choose to care.

Participation promotes caring.

6. *Seek Advice and Support but Don't Wait for Approval*
The financial support, advice, information, and stories we received from the community were critical. We actively sought such input but were careful to retain the initiative and responsibility for the project. We began work without knowing if or when it would be published. We spent time and money without knowing we could get support. Had we been unwilling to take these risks, the project would not have come to fruition.

7. *Sources of Historic Photographs*
In Albuquerque we are lucky to have the Albuquerque Museum's extensive collection of historic photographs. This was the source for the majority of our historic images. Additional sources we could have used include the Center for Southwest Research at the University of New Mexico, applications for historic designation held by the city, state and federal governments, collections held by various agencies such as the Middle Rio Grande Conservancy District, records of local newspapers, and private collections of longtime residents.

8. *Sources of Information*
We consulted a large variety of sources for information about our sites, including interviews of people living near the sites, historic nominations, newspaper articles, the city directory, USGS maps, Sanborn maps, plat and permit records of the city, published histories, architectural guides and histories, and architectural and planning theories developed at the University of New Mexico.

9. *Good Ideas We Didn't Try*
Third Images: Jim Moore, director of the Albuquerque Museum at the time of the original project, suggested that we add a third photo to the pairs. This third image would present an alternative approach to the issue raised by the historic comparison. For example, when we discussed the redevelopment of the old Albuquerque High School, we could have added a photograph of a successful redevelopment of a historic high school building in Seattle.

Full Historic Record: In some cases available photographs of a site are from more than one time. For example, there are images of the Champion Building available from a number of different decades. Had we included these multiple images, we may have more strongly evoked the continuity of change.

Site Plans: Our original intent was to include historic and current site plans. The purpose was to provide information on the context of the sites and to provide the public with the tools to more critically evaluate proposals for future development (which are typically presented in plan form). Sanborn maps and USGS maps could have provided most of the information for the historic site plans. We did not include these plans because of time constraints and because of the apparent unavailability of some of the necessary information when we started the project.

BIBLIOGRAPHY

Works Cited

Anaya, Rudolfo. 1992. *Alburquerque*. Albuquerque: University of New Mexico Press.

Bank of America, California Resources Agency, Greenbelt Alliance, and the Low Income Housing Fund. 1995. "Beyond Sprawl: New Patterns of Growth to Fit the New California." Accessed October 3, 2017. www.calwater.ca.gov/Admin_Record/C-057784.pdf.

Bogle, John C. 2009. *Enough: True Measures of Money, Business, and Life*. Hoboken, NJ: John Wiley and Sons.

Brennan, Emily. 2013. "Albuquerque's Role on 'Breaking Bad.'" *New York Times*, August 6. http://www.nytimes.com/2013/08/11/travel/albuquerques-role-on-breaking-bad.

Bruce, Cynthia Sue. 1982. "Los Griegos: Nomination to the National Register of Historic Places and Design Guidelines." Master's thesis, University of New Mexico.

Childs, Mark C., and Ellen D. Babcock. 2016. *The Zeon Files: Art and Design of Historic Route 66 Signs*. Albuquerque: University of New Mexico Press.

City of Albuquerque. 2015. "City Council Meeting, April 6, 2015," video recording, 5:51:57. http://cabq.granicus.com/MediaPlayer.php?view_id=2&clip_id=116.

Crouch, Dora P., Daniel J. Garr, and Axel I. Mundigo. 1982. *Spanish City Planning in North America*. Cambridge, MA: MIT Press.

Fausold, Charles J., and Robert J. Lilieholm. 1996. "The Economic Value of Open Space: A Review and Synthesis." Lincoln Institute of Land Policy Working Paper. Cambridge, MA: Lincoln Institute of Land Policy.

Freeland, Richard C. 2005. "Universities and Cities Need

to Rethink Their Relationships." *Chronicle of Higher Education*, May 13.

Gore, Al. 1998. "Remarks by Vice President Al Gore [at] the Brookings Institution, Wednesday September, 2. 1998." Vice President Gore's National Partnership for Reinventing Government. Accessed November 6, 2017. https://govinfo.library.unt.edu/npr/library/speeches/090998.html.

Gray Faust, Chris. 2013. "'Breaking Bad' Has Been Very Good for Albuquerque." *USA Today*, August 11. https://www.usatoday.com/story/travel/destinations/2013/08/11/breaking-bad-albuquerque-tourism/2636859/.

Greenfield, Cory. 1998. "Mapping the Architecture of the City: Physical Consequences of Land Subdivision Patterns in Albuquerque, NM." Master's thesis, University of New Mexico.

Hartranft, Michael. 1995. "City Fells Montaño Landmark." *Albuquerque Journal*, December 28.

Hooker, Van Dorn. 2000. *Only in New Mexico: An Architectural History of New Mexico, 1889–1989*. Albuquerque: University of New Mexico Press.

Kennedy, Roger G. 2004. *Mr. Jefferson's Lost Cause: Land, Farmers, Slavery, and the Louisiana Purchase*. Oxford: Oxford University Press.

Korten, David C. 2010. *Agenda for a New Economy: From Phantom Wealth to Real Wealth*. San Francisco, CA: Berret-Koehler Publishers.

Kostof, Spiro. 1991. *The City Shaped: Urban Patterns and Meanings through History*. Boston, MA: Bullfinch.

Lamadrid, Enrique, and Jerry Gurulé. 2013. "*Encuentros con los Antepasados*: Flood, Salvage Archaeology, and Community." *Chronicles of the Trail* 9 (1): 21.

Leopold, Aldo. 1949. *A Sand County Almanac*. London: Oxford University Press.

Louv, Richard. 2008. *Last Child in the Woods: Saving Our Children from Nature Deficit Disorder*. Chapel Hill, NC: Algonquin Books.

Macías, Vanessa. 2007. "'En Unidad, Hay Poder': Community Activism and Ethnicity in South Martineztown, 1930–1974." *New Mexico Historical Review* 82 (1): 71–96.

Martínez, Valerie. 2014. "Art and Community Change." *Green Fire Times* 6 (7): 8, 19. Accessed November 7, 2017. http://greenfiretimes.com/wp-content/uploads/2014/06/GFT-July-2014-V6N7.pdf.

McDonald, Ian. 2010. *The Dervish House*. Amherst, NY: Pyr.

Perkins + Will. 2017. "Adaptive Reuse." Accessed October 9, 2017. https://perkinswill.com/service/adaptive-reuse.

Ribbat, Christoph. 2013. *Flickering Light: A History of Neon*. London: Reaktion Books.

Rivera, José A. 1998. *Acequia Culture: Water, Land, and Community in the Southwest*. Albuquerque: University of New Mexico Press.

Sargeant, Kathryn, and Mary Davis. 1986. *Shining River,*

Precious Land: An Oral History of Albuquerque's North Valley. Albuquerque, NM: Albuquerque Museum.

Shakespeare, William. 1998. *The Tragedy of Hamlet, Prince of Denmark*. With new and updated critical essays and a revised bibliography by Sylvan Barnet. New York: Signet Classic.

Speck, Jeff. 2014. "Albuquerque, New Mexico, Downtown Walkability Analysis." Accessed November 7, 2017. Attachment 1, Downtown Walkability Analysis, https://www.cabq.gov/council/find-your-councilor/district-2/projects-planning-efforts-district-2/downtown-walkability-study.

Stautberg, Tim. 2008. "Albuquerque Tribune to Cease Publication." Scripps. Accessed April 21, 2016. http://www.scripps.com/press-releases/646.

Strunk, William, Jr., and E. B. White. 1979. *The Elements of Style*. New York: Macmillan.

UNM. 2017. "Regents' Policy Manual—Section 1.1: Responsibilities of the Board of Regents." Accessed November 7, 2017. https://policy.unm.edu/regents-policies/section-1/1-1.html.

UNM School of Architecture and Planning. 2013. "ABQ UNM CityLab Studio: Parquitos Project." YouTube video, 3:25. Posted by "UNM SA•P." September 10. https://www.youtube.com/watch?v=YA9ICmodtno.

US Federal Works Agency. 1947. *Final Report on the WPA, 1935–43*. Washington, DC: US Government Printing Office.

US Fish and Wildlife Service. 2016. "About the Refuge." Last modified November 20, 2016. https://www.fws.gov/refuge/Valle_de_Oro/about.html.

Weiner, Eric. 2016. *The Geography of Genius: A Search for the World's Most Creative Places from Ancient Athens to Silicon Valley*. New York: Simon and Schuster.

Weiss, Marc A. 1987. *The Rise of the Community Builders: The American Real Estate Industry and Urban Planning*. New York: Columbia University Press.

A Short List of Sources on Rephotography

Baars, Donald L., Rex Buchanan, and John R. Charlton. 1994. *The Canyon Revisited: A Rephotography of the Grand Canyon, 1923/1991*. Salt Lake City: University of Utah Press.

Blesse, Robert E., and Peter Goin. 1988. *Nevada's Evolving Landscape*. Reno, NV: Senator Alan Bible Center for Applied Research of the College of Arts and Science, University of Nevada-Reno.

Dingus, Rick. 1982. *The Photographic Artifacts of Timothy O'Sullivan*. Albuquerque: University of New Mexico Press.

Dutton, Alan A., and Diane Taylor Bunting. 1981. *Arizona, Then and Now: A Comprehensive Rephotographic Project*. Phoenix, AZ: Ag2 Press.

Garvey, Susan Gibson, Marlene Creates, Patricia Deadman, Lorraine Gilbert, Ernie Kroeger, Sandra Semchuk, and Sylvie Readman. *Rephotographing the Land: Marlene Creates, Patricia Deadman, Lorraine Gilbert, Ernie Kroeger, Sylvia Readman, and Sandra Semchuk.* Halifax, NS: Dalhousie Art Gallery.

Goin, Peter, and Lucy R. Lippard. 2013. *Time and Time Again: History, Rephotography, and Preservation in the Chaco World.* Santa Fe: Museum of New Mexico Press.

Goin, Peter, C. Elizabeth Raymond, and Robert E. Blesse. 1992. *Stopping Time: A Rephotographic Survey of Lake Tahoe.* Albuquerque: University of New Mexico Press.

Green, Raymond James. 1983. "Determining Perceived Environmental Change within Tucson Using a Rephotographic Technique." Master's thesis, University of Arizona.

Klett, Mark, Ellen Manchester, and JoAnn Verburg. 1984. *Second View: The Rephotographic Survey Project.* Albuquerque: University of New Mexico Press.

Klett, Mark, Kyle Bajakian, William L. Fox, Michael Marshall, Toshi Ueshina, and Byron G. Wolfe. 2004. *Third Views, Second Sights: A Rephotographic Survey of the American West.* Santa Fe: Museum of New Mexico Press.

Martini-Fuller, Kevin J. 1993. "A View of the Present through the Past: A Social Rephotographic Perspective of Cairo, Illinois." Unpublished research paper (MFA), Southern Illinois University at Carbondale.

Norman, James B. 1994. *Oregon Main Street: A Rephotographic Survey.* Portland: Oregon Historical Society Press.

Tamraz, Nihal, and Barry Iverson. 1989. "Rephotographing Egypt: Double Vision." *Aramco World* 40 (4): 6–15.

Webb, Robert H. 1996. *Grand Canyon, a Century of Change: Rephotography of the 1889–1890 Stanton Expedition.* Tucson: University of Arizona Press.

Wilson, Susan E. 1984. "Rephotography: A Look at Rephotography in the Past Ten Years with Original Rephotography Work of Athens and Atlanta." Master's thesis, University of Georgia.

Wolfe, Byron, and Scott Brady. 2017. *Phantom Skies and Shifting Ground: Landscape, Culture, and Rephotography in Eadweard Muybridge's Lost Illustrations of Central America.* Philadelphia, PA: Temple University Press; Santa Fe, NM: Radius Books.

A Short List of Sources on Albuquerque's History

Albuquerque Industrial Development Service, Industrial Foundation of Albuquerque, and University of New Mexico. Environmental Research and Development Center. 1972. *Albuquerque Factbook.* Albuquerque, NM: Albuquerque Industrial

Development Service and Industrial Foundation of Albuquerque.

Albuquerque Planning Department. 1958. *Old Albuquerque Historic Zone, 1706–1958*. Albuquerque, NM: Albuquerque Planning Department.

Balcomb, Kenneth C. 1980. *A Boy's Albuquerque, 1898–1912*. Albuquerque: University of New Mexico Press.

Barnhart, Jan Dodson, and University of New Mexico Center for Southwest Research. 2006. *Albuquerque, New Mexico, USA: Resources and Research Collections: A Guide to Selected Published Materials and Archival Resources*. Albuquerque, NM: Legacy Media.

Biebel, Charles D. 1986. *Making the Most of It: Public Works in Albuquerque during the Great Depression, 1929–1942*. Albuquerque, NM: Albuquerque Museum.

Fergusson, Erna. 1947. *Albuquerque*. Albuquerque, NM: M. Armitage.

Gill, Donald A. 1994. *Stories Behind the Street Names of Albuquerque, Santa Fe, and Taos*. Chicago, IL: Bonus Books.

Johnson, Byron A., and Robert K. Dauner, eds. 1981. *Early Albuquerque: A Photographic History, 1870–1918*. Albuquerque, NM: Albuquerque Journal and Albuquerque Museum.

Johnson, Byron A., and Sharon Peregrine Johnson. 1983. *Gilded Palaces of Shame: Albuquerque's Redlight Districts, 1880–1914*. Albuquerque, NM: Gilded Age Press.

Palmer, Mo. 2006. *Albuquerque Then and Now*. San Diego, CA: Thunder Bay Press.

Price, V. D. 1992. *A City at the End of the World*. Albuquerque: University of New Mexico Press.

Pyle, Ernie, and Reeve Spencer Kelley. 1942. *Why Albuquerque?* Santa Fe, NM: Bureau of Publications.

Reynolds, Kristen. 2016. *Wings of War: An Illustrated History of Kirtland Air Force Base, 1941–1960*. Albuquerque, NM: Kirtland Air Force Base.

Rosner, Hy, Joan Rosner, and Kathleen Norris Peak. 1996. *Albuquerque's Environmental Story: Toward a Sustainable Community*. Albuquerque, NM: H. and J. Rosner.

Scurlock, Dan. 1998. "From the Rio to the Sierra: An Environmental History of the Middle Rio Grande Basin." General Technical Report RMRS-GTR-5. Fort Collins, CO: US Department of Agriculture, Forest Service, Rocky Mountain Research Station.

Simmons, Marc. 1982. *Albuquerque: A Narrative History*. Albuquerque: University of New Mexico Press.

———. 2003. *Hispanic Albuquerque, 1706–1846*. Albuquerque: University of New Mexico Press.

Anthony Anella is a conservationist, architect, and writer. Born and raised in Albuquerque, he is the father of three children, who were also raised in Albuquerque. He is the principal of Anthony Anella Architecture, an award-winning design practice. From 2000–2003 he helped protect 30,828 acres of the Montosa Ranch with a conservation easement. This project, located near Magdalena, New Mexico, is profiled in *Saving the Ranch: Conservation Easement Design in the American West* (Island Press 2004), which he coauthored. From 2005–2009 he served on the board of the New Mexico Land Conservancy, and from 2009–2015 he served on the national board of the Aldo Leopold Foundation. He is the founder of the Leopold Writing Program, a New Mexico nonprofit dedicated to promoting environmental ethics through the written word.

Professor, architect, and public speaker **Mark C. Childs**, AIA, is the associate dean for research for the School of Architecture and Planning at the University of New Mexico. Mark is the author of the 2017 New Mexico Heritage Preservation Award winner *The Zeon Files: Art and Design of Historic Route 66 Signs* with Ellen B. Babcock (UNM Press 2016; see New Mexico PBS *¡Colores!* episode, http://portal.knme.org/video/2365799822/), *Urban Composition: Developing Community through Design* (Princeton Architectural Press 2012; EDRA Award winner 2013), *Squares: A Public Place Design Guide for Urbanists* (UNM Press 2004; Planetizen Top Ten Books 2005), and *Parking Spaces: A Design, Implementation, and Use Manual for Architects, Planners, and Engineers* (McGraw-Hill 1999), as well as numerous book chapters, articles, and poems. He is a Fulbright Scholar (Cyprus 2005) and has won awards for community engagement, teaching, public art, heritage preservation, and poetry. Students in his courses have won Congress of New Urbanism, American Institute of Architecture, and American Planning Association awards. Mark works across disciplines, roles, and administrative structures to help create soul-enlivening, resilient, healthy, and environmentally sound communities.

INDEX

Page numbers in italic text indicate illustrations.